CW00735546

MOHOLY-NAGY
IN BRITAIN
1935–1937

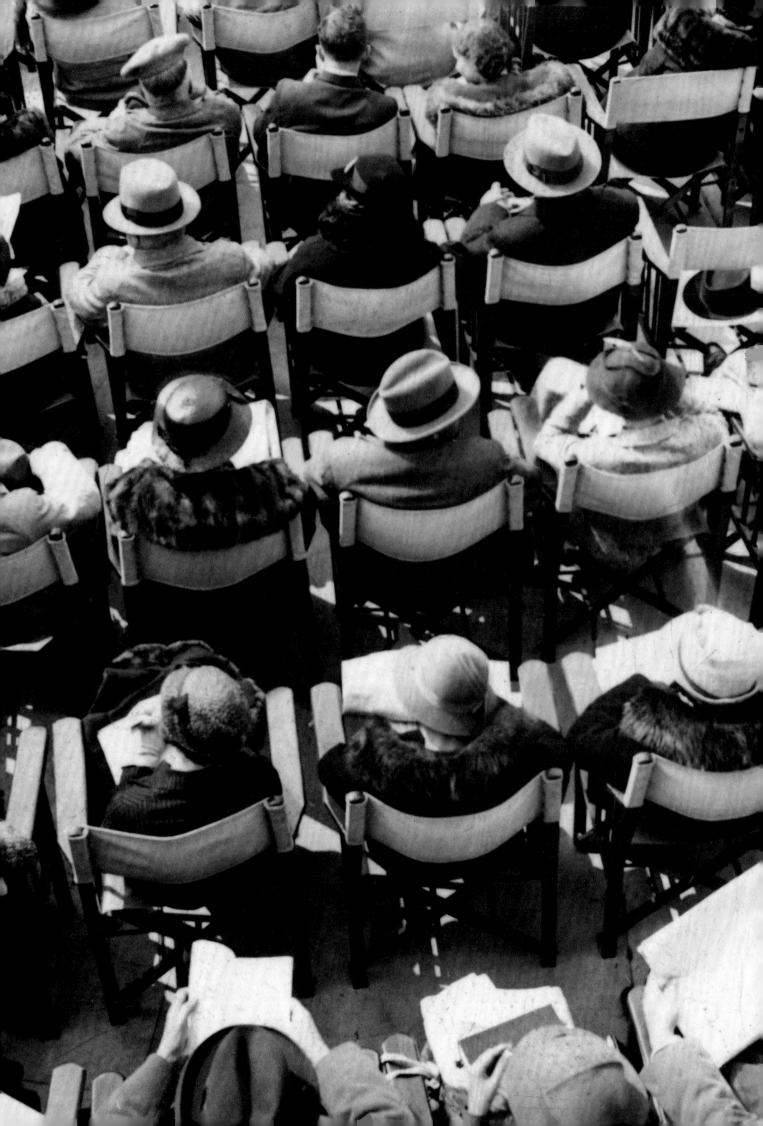

Valeria Carullo

MOHOLY-NAGY IN BRITAIN

1935–1937

First published in 2019 by Lund Humphries

Lund Humphries
Office 3, Book House
261A City Road
London EC1V 1JX
UK

www.lundhumphries.com

Moholy-Nagy in Britain: 1935-1937 © Valeria Carullo, 2019
All rights reserved

ISBN: 978-1-84822-376-9

A Cataloguing-in-Publication record for this book is
available from the British Library

All rights reserved. No part of this publication may be
reproduced, stored in a retrieval system or transmitted
in any form or by any means, electrical, mechanical or
otherwise, without first seeking the permission of the
copyright owners and publishers. Every effort has been
made to seek permission to reproduce the images in
this book. Any omissions are entirely unintentional,
and details should be addressed to the publishers.

Valeria Carullo has asserted her right under the
Copyright, Designs and Patent Act, 1988, to be
identified as the Author of this Work.

Copy edited by Eleanor Rees
Designed by Adrian Hunt from an original
concept by Valeria Carullo
Set in Azo Sans and Rockwell Nova
Printed in United Kingdom

The publishers gratefully
acknowledge the support of RIBA

RIBA
Architecture.com

Previous page:
László Moholy-Nagy's photograph
featured in 'Leisure at the Seaside',
Architectural Review, July 1936

This page:
De La Warr Pavilion, Bexhill-on-Sea
(photograph: László Moholy-Nagy)

CONTENTS

FOREWORD

I am most pleased to be able to introduce to you Valeria Carullo's new book on László Moholy-Nagy's British oeuvre, an oft-overlooked but highly productive period of the artist's life. Moholy-Nagy was one of the most influential teachers, designers and theoreticians of 20th-century Modernism.

Born in Bácsborsód, Hungary, in 1895, he moved to Budapest in 1913 to study law, where he joined Lajos Kassák's 'Activist' group in 1918. Kassák's Socialism and the 1919 Hungarian Soviet Republic instilled in Moholy-Nagy a lifelong universalist utopianism. He settled in Berlin in 1920, where Raoul Hausmann's, Hannah Höch's and Kurt Schwitters' inter-medial Dadaism broadened his notion of art. He learned of Biocentrism and Reform Pedagogy through his first wife, Lucia Moholy, who became a well-known portrait photographer during their time in London. Encountering Russian Constructivism in 1921, he began making material constructions and abstract paintings influenced by Kasimir Malevich and Lazar El Lissitzky.

As a professor at the Bauhaus (1923–8) and a central figure of International Constructivism, he pioneered modern interdisciplinary art and design practice and opposed traditional media hierarchies, thereby heralding the post-war media art revolution. In 1922–3 he prefigured conceptual art in the *Emaille* [enamel] series, ordered from an enamel signmaker using graph paper sketches and standardised colours. With Walter Gropius, he edited *bauhaus* magazine (1926–8) and the *Bauhausbücher* series (1925–9). His design for these publications heralded a new phase in graphic and typographic design. In his own seminal contribution to this series, *Malerei, Photographie, Film* [Painting, Photography, Film], published in 1925, he set out a key manifesto of 20th-century media art, in which he regarded technology as an extension of our sensorium, influencing media theorists Walter Benjamin, Sigfried Giedion and Marshall McLuhan. While he had been making photograms since 1922 (in collaboration with Lucia Moholy), it was only in 1925 that he began making camera photographs, supported by Moholy's expertise in that field. Regarding light as 'raw material', Moholy-Nagy saw painting as just one possible form of 'light art', on a continuum from light projections, through photograms, photographs and film, to media of applied pigment. He conceptualised expanded cinema, and coined the term 'New Vision' to refer to his call for sensory training for modernity and his reform of photography based on the camera's technical capabilities. His paintings, photograms, photographs and photomontages influenced contemporary practice, and his incorporation of photographic enlargements and photomontages into stage sets, exhibition designs and commercial interiors (sometimes projected), were innovative and influential.

After the Bauhaus, he pursued a successful design practice in Berlin (1928–34). Partly with the assistance of his second wife, Sibyl, he made a series of documentary films about urban life (1929–33). His mechanised 'Light

Prop for an Electric Stage' (1930) was designed to help produce abstract films, but was also to be used to project kinetic coloured light on the stage, and inspired post-war kinetic light art. His later life in the English-speaking world was portended by the appearance of the English translation of his second Bauhaus book, *Von Material zu Architektur* [From Material to Architecture] as *The New Vision* (London and New York, 1932).

The deteriorating situation in Germany induced him to move to Amsterdam and then London. Aside from the research with Terrence Senter carried out in the 1970s, very little is known about Moholy-Nagy's British period and Carullo has succeeded in increasing our knowledge greatly. Her work on documenting and discussing Moholy-Nagy's little-known but outstanding commercial interiors is nothing short of sensational. She has also given us a more thorough analysis of his British photographic practice; this is the only time in his life that Moholy-Nagy made money from his camera photography, and she has shown that his documentary photo essays of British educational institutions were of importance. In addition, she has also shed new light on his film-making activity in Britain. Finally, she has demonstrated the extent to which Moholy-Nagy was part of a tight-knit and supportive creative and intellectual community in London, something that he had been searching for since his life in Berlin had collapsed in 1933, and something that it would be difficult to argue he found to this extent in Chicago. Moholy-Nagy's British experience changed him.

In 1937, Moholy-Nagy was called by Walter Gropius to become Director of the 'New Bauhaus' in Chicago, an offer it would have been difficult for him to refuse. He opened the School of Design in 1939 and taught in Chicago until his death in 1946. His books *The New Vision* and *Vision in Motion* (1947) are among the most influential post-war design treatises in the English-speaking world. While it is his American period that receives most attention in the literature, as far as his post-German life is concerned, Carullo has amply demonstrated that not only did Moholy-Nagy receive a warm welcome in Britain, he seems to have enjoyed himself and may well have elected to remain had the offer from Gropius not come up.

Oliver Botar
Oliver Botar is a Professor of History of Art at the University of Manitoba, Canada. An expert on early 20th-century Central European Modernism, and particularly on the work of Moholy-Nagy, he has curated exhibitions and written numerous articles, catalogues and books, including Sensing the Future: Moholy-Nagy, Media and the Arts *(2014).*

MOHOLY-NAGY IN BRITAIN: 1935–1937

Right:
Portrait of László Moholy-Nagy
(photograph: László Moholy-Nagy and Lucia Moholy, 1926)

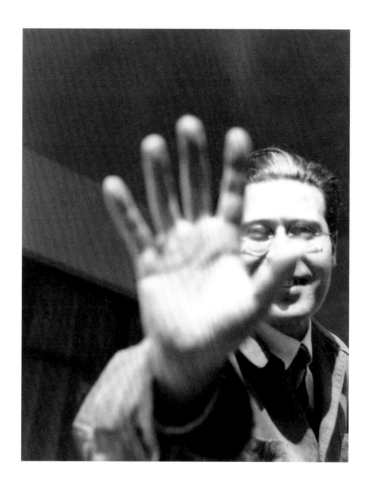

László Moholy-Nagy (1895–1946) was one of the most innovative artists and thinkers of the first half of the 20th century. He worked across a variety of media, including photography, film, painting and graphic design, and was a talented and inspirational teacher. Born in Hungary, he established his career in Berlin and then taught at the Bauhaus in Dessau. He eventually emigrated to the United States after spending two years in Britain in the mid-1930s – an intense period filled with commissions, collaborations, opportunities, disappointments, artistic exchanges and friendships.

On 10 November 1933 László Moholy-Nagy set foot
in Britain for the first time. His arrival was announced
by the *Architects' Journal*, which, along with its sister
publication the *Architectural Review*, had been publishing
his bird's-eye view compositions to illustrate articles
on modern photography. These articles attest to the
fact that Moholy's reputation among modernist British
architects was based both on his pivotal role at the
Bauhaus Dessau and on his photographic work. In the
28 September 1933 issue of the *Architects' Journal* he
was defined as 'the most eminent and revolutionary
architectural photographer living': an interesting, if partial,
interpretation of Moholy-Nagy's work that nevertheless
reflects his lifelong involvement with architecture.

Right:
Architects' Journal, 16 November 1933, p.623

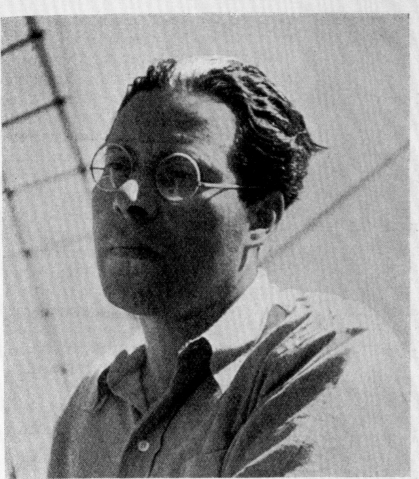

*Professor Moholy-Nagy, late of " The Bauhaus,"
Dessau, who arrived in England on Friday last.*

...ow a fine speaking voice can be ruined by reverberation,
...nd a bad one magnified far beyond its true value.

*

Acoustics are troublesome, Dr. Desmond MacMahon.
A concert hall and a meeting hall have many points of
difference. But don't blame the architect for physical
facts—nor grouse when he obeys the orders of his client,
however stupid you consider those orders to have been.

THE R.S.A. AND INDUSTRIAL DESIGN

It was my good fortune to sit between the chairman of a
big industrial firm in the north, and the sales manager of a
big industrial firm in the south, at the Royal Society of Arts
dinner last week at Merchant Taylors' Hall. They were
completely in agreement over every point made by the
Prince of Wales, who spoke on art in industry, with par-
ticular reference to the Royal Academy Exhibition of
British Art in Industry to be held in 1935.

*

The Prince had said : " All forms of experts, except
...rtists have been employed because manufacturers have

form. The talks have
revised, and are to be issu

A SPECIOUS ARGUMENT
A letter in Monday's *L*
ously glib suggestion to
builder " is not to blame a

" No section of the busir
" has done more than th
desperate public need."

Thus he administers a
jerry-builder—and then g
local authorities, who hav
given to them by Parliame

Although the matters of
planning are not without
regret that so many opp
slide for, in some cases, in

Passing-on-the-blame is
but so far as the specula
most other cases, " two bl

Nor is it any the less wr
can stand up to a tolerant
self of blame on the grou
powers to stop you from g

THE ARCHI

FILM: ARCHITECTS' CONGRESS

Eight "stills" from the film, Architects' Congress, made by Professor L. Moholy-Nagy as a diary of the fourth Congress of the C.I.A.M., and exhibited in London last week by the Film Society.

The Congress was held last summer on board the s.s. "Patris II," cruising in the Mediterranean and visiting Athens and the Greek Islands. England was represented by delegates from the M.A.R.S. (Modern Architectural Research) group.

1. Architects on the deck of s.s. "Patris II," leaving Marseilles, July 29.
2. S.S. "Patris II" entering the Corinth Canal, July 31.
3. Delegates in seance on the Mediterranean.
4. Arrival at Piraeus for Athens.
5. Temple of Jupiter, Athens.
6. A fallen column, Temple of Jupiter.
7. J. Louis Sert, Spanish delegate.
8. Alfred Roth, Swiss delegate.

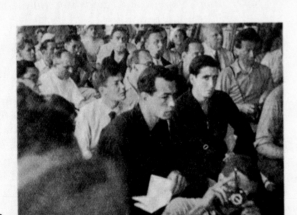

Another shot from the film is given as this week's frontispiece.

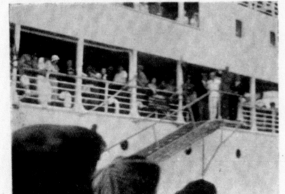

BY
MOHOLY-
NAGY

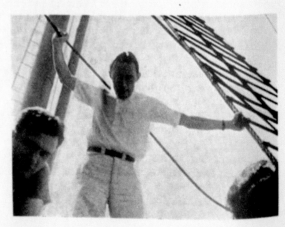

In the summer of 1933, Moholy-Nagy had attended the fourth CIAM (Congrès internationaux d'architecture moderne) congress in Athens and documented it in a film-diary which was featured in the *Architects' Journal* in December of the same year. At the congress he was approached about a possible move to England by Philip Morton Shand, an architectural critic and founding member of MARS (Modern Architectural Research, the group of British architects affiliated to CIAM), who would be instrumental the following year in the relocation to London of Moholy-Nagy's friend and mentor (and Bauhaus founder) Walter Gropius. At the CIAM congress Moholy-Nagy also met other MARS representatives, as well as fellow Hungarian Ernö Goldfinger, who himself settled in London in 1934, going on to become one of the most influential architects in post-war Britain.

Left:
Architects' Journal, 21 December 1933, p.792

Following Hitler's rise to power in 1933, life became increasingly difficult in Germany for avant-garde artists and modernist architects, especially those of Jewish origin. Like many others, Moholy started to consider leaving Berlin, where he had been based since 1928. His exploratory visit to London in November 1933 was therefore motivated by more than the promise of an exhibition of his graphic work, due to be organised by the well-known American designer Edward McKnight Kauffer. The exhibition did not materialise, but Moholy had the opportunity to renew his acquaintance with Ben Nicholson and Barbara Hepworth – both of whom he had probably first met in Paris earlier in the year – and to be introduced to art historian Herbert Read, who would become one of his closest friends and advocates, recognising in Moholy 'one of the most creative intelligences of our time'.[1] In London he also met his friends Alvar and Aino Aalto and helped them arrange the display of their plywood furniture for an exhibition held at Fortnum & Mason, organised by Morton Shand with the support of the *Architectural Review*. Moholy attended the opening on 13 November with the science reporter J.G. Crowther, who had been his first English client, and for whom he had designed the cover of the book *An Outline of the Universe* in 1930. In a letter to his future wife Sibyl Pietzsch on 22 November 1933, Moholy remarked: 'positive things till now not many, but negotiations. [Morton Shand's] friendship grows'.[2]

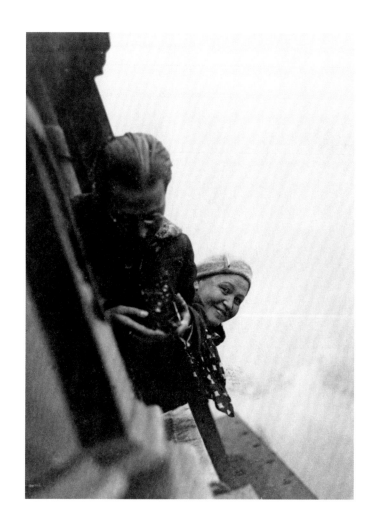

Above:
László Moholy-Nagy and Aino Aalto watching the opening ceremony of the British Parliament in London in 1933 (photograph: Alvar Aalto)

Right:
Cover of *An Outline of the Universe* (artwork: László Moholy-Nagy, 1930)

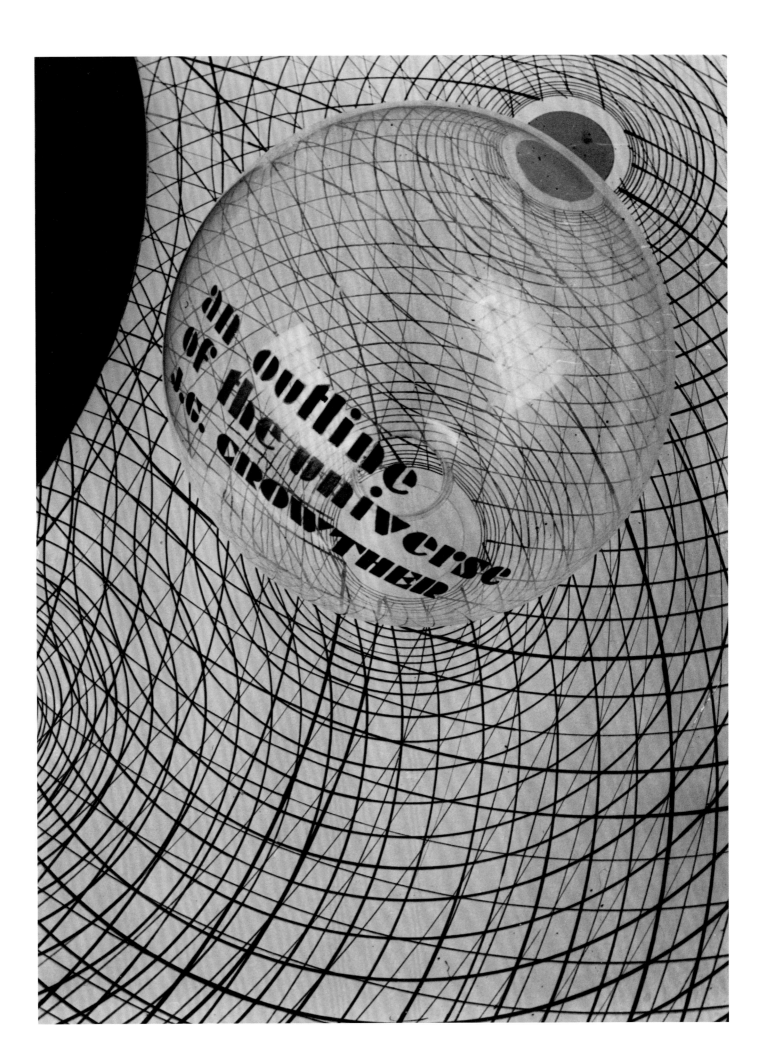

new eyes for old

by p. morton shand

Street *Moholy-Nagy*

LIKE the steam locomotive, photography is barely a century old. Paradoxically enough it had to wait for the painter to divine its imaginative potentialities. And still more paradoxically, the painter was only free to reveal them after a drastic frontier revision of his own province. Now it is self-evident that for accuracy of facsimile eye+hand cannot compete with eye +lens, the pencil-point with the printing-frame. The Impressionists were the first to realize the implications of this simple conclusion. By making colour theme as well as medium they sounded the knell of representational art. Anyone who has seen the Hon. John Collier's famous decomposition, *Sentence of Death*, will realize that the artist's idealized Harley Street specialist was really an Elliott and Fry coroner holding a belated inquest on a corpse already pretty far gone. Thus the province of photography became defined as what seems the direct negation of art : reproduction.

The historical evolution of photography can be very briefly resumed. Up till the last decade it was employed in two ways : either "artistically," or as a mechanical means of recording the obvious semblance of things. The "artistic" uses were artistically negligible because they were as purely imitative as machine-made emulations of handicraft characteristics. From the Victorian Christmas card to Vorticism, every successive phase of nineteenth-century painting was faithfully mimed by the men who disappeared under black velvet cowls as ritualistically as "real" artists donned velvet jackets. In straightforward reproduction, on the other hand, the most far-reaching advances in technique were made. Here science showed the way back to art. But being "soullessly mechanical" these progressive perfections were treated as of as little importance as the invention of the half-tone block and the rotary press. All those who "took up art seriously," or had a "true feeling" for it, scorned photography. The cultural gulf between painters and photographers was as profound as the social gulf between barristers and solicitors. True, academicians like Herkomer, notable pioneer in the mass-production of "speaking likenesses," deigned to use photographic labour-saving devices for quick-service portraiture. But this no more implied a budding identity of the two professions than did the hand-colouring of family groups by humble local photographers.

Though Art continued to hold a mirror up to Nature which photography showed to be cracked and fly-blown, Bohemia remained gay and exclusive as ever.

" Photography considered as the art of representation does not mean the mere copying of nature. This is shown by the comparative rareness of a 'good' photograph. Among the millions reproduced in books and papers it is only every now and then that we come across a really fine one. And the odd thing is, though proof in itself, that we instinctively pick out these 'good' photographs, regardless of the strangeness of their 'themes,' once we have trained our vision to formulate new criteria for chiaroscuro effects and close-up textures arrested in a hundredth or thousandth of a second."*

" Through the development of photography light and shade were for the first time fully revealed, and employed with something more than purely theoretical knowledge. Through the development of reliable artificial illumination, and the power of regulating it, an increased adoption of flowing light and richly graduated shadows ensued ; and through these again a greater animation of surface, and a more delicate optical intensification. This manifolding of graduations of tone is one of the fundamental 'materials' of optical formalism—which still holds good if we pass beyond the immediate sphere of black-white-grey values to coloured ones."†

With the advent of the films it began to be realized that photographic representation, if treated selectively, could be at once a key to the significant or exceptional, and a synthesis of the general aspects of either single objects, or complexes of objects in juxtaposition ; and that this would open up an entirely new field in art. To anticipate, recognize, and seize these transient self-patterns and chance designs postulated the kind of "eye for form" in whose retina a "perfect sunset" would be reflected as

* *Malerei, Fotografie, Film.* By L. Moholy-Nagy. Munich : Albert Langen Verlag, 1927.
† See note on next page.

11

Less than two months later, in the January 1934 issue of the *Architectural Review*, Morton Shand penned a seminal article on the relationship between architecture and photography, titled 'New Eyes for Old'. Establishing a direct link between the New Vision – the avant-garde photography movement of which Moholy-Nagy was the main proponent – and the development of modern architecture, he hailed Moholy as 'the leading architectural photographer' and utilised Moholy's images to strengthen his argument. In the meantime, the political climate in Germany was becoming increasingly oppressive, and that same month Moholy wrote to Herbert Read, expressing his dismay at the state of affairs in Berlin.

"The situation of the arts around us is devastating and sterile. One vegetates in total isolation, persuaded by newspaper propaganda that there is no longer any place for any other form of expression than the emptiest phraseology. […] It is therefore a great joy to know that you exist and that you are a friend; and that you share the opinions of the small group of us who are here in isolation."

Moholy-Nagy to Herbert Read, Berlin, 24 January 1934[3]

Left:
Architectural Review, January 1934, p.11

Shortly afterwards he left for Amsterdam, accepting a job with the design agency Pallas Studio, set up by his former patron Ludwig Katz, who had also fled Berlin. Together they launched the new periodical *International Textiles*, with Moholy as art director. During this period he also experimented with colour photography, and studied Kodak's dye-transfer method during his second short visit to London in August of that year with the help of his ex-wife, the photographer Lucia Moholy, who had recently moved to Britain. Throughout 1934 he exchanged letters with Ben Nicholson and Barbara Hepworth, while Herbert Read tried to stage an exhibition of his work at the Mayor Gallery. Read also enlisted Moholy's help to source the illustrations for his influential book of that year, *Art and Industry*, and in its introduction described how the artist's *The New Vision* (which had recently been translated into English) had given him 'the necessary impetus' to write it.

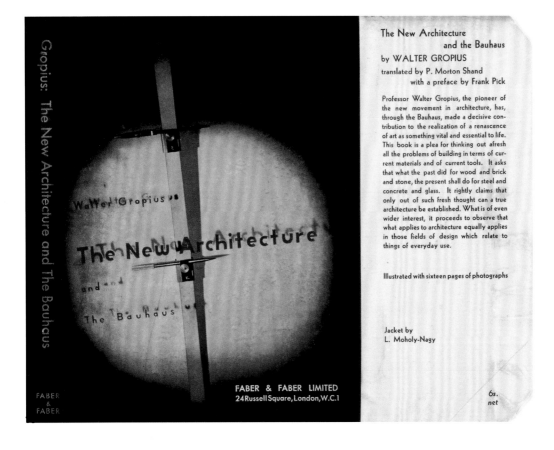

Left:
Cover jacket for *The New Architecture and the Bauhaus* by Walter Gropius (artwork: László Moholy-Nagy, 1935)

In October 1934 Walter Gropius emigrated to London, helped by Morton Shand, Jack Pritchard and the architect Maxwell Fry. This event was a decisive factor in Moholy-Nagy's subsequent decision to leave Amsterdam, a city that no longer seemed to offer sufficient creative opportunities. During his final preliminary visit to London in January 1935, he visited Gropius at the Lawn Road Flats in Hampstead, where the architect had been living since his arrival, and the two engaged in an intense correspondence during the first few months of that year. However, it was not only Gropius's encouragement and the opportunity to work with him again that made England such an attractive proposition for Moholy; according to Sibyl, he had been reading Voltaire's *Lettres philosophiques sur les anglais,* which confirmed his opinion of the country as a refuge from repression and intolerance.

"The British tradition of free thinking gave his first London years the exuberance of a confirmed faith […] Tolerance towards convictions as well as towards eccentricity; the love of understatement and self-irony; a plain seafaring sense of humor; the cool pride in being what one is – insular and English – and, above all, English amateurism, constituted a perfect psychological coincidence […] The German tendency to forgo a full life for the accumulation of maximum information or maximum skill in one specialized field was alien to his nature […] England was the country of the amateur – it was his country."

Sybil Moholy-Nagy, *Moholy-Nagy: Experiment in Totality*[4]

TEXTILE DISPLAY
BY L. MOHOLY-NAGY

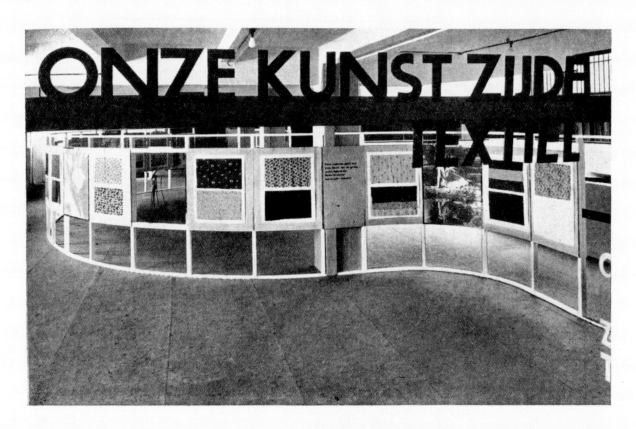

PROFESSOR L. MOHOLY-NAGY was responsible for the design of the current exhibition at Utrecht of the Dutch Artificial Silk Industry. Some 7-800 dress fabrics were chosen out of as many thousands, and displayed in four different ways :—

1 : On a large screen faced with three-ply curving in and out of the far end of the hall. Here the materials were shown in small frames, like an enlarged book of patterns with sheets of glass painted with fashion-plates between them to give a through vista to the other end of the room. Alternating with these were full-sized photographic enlargements.

2 : A main feature on the opposite wall in the form of twin cascades of materials in carefully harmonized and contrasted colourings.

3 : Two stands covered with nickelled plating fitted with vertical sheets of glass between which expanses of fabrics were billowed out lengthways by an arrangement of bent tubing. In the same partition were five life-sized fashion-plate figures to which fabrics were glued.

4 : A corner in which five table-cloths were suspended from the wall at a falling angle on dummy table-tops.

Raw material was represented by a loom-shaped arrangement of rayon bobbins hung on wires, and a glass case filled with pigments used in dyeing. The walls were covered with thin, and the floor rather stouter, bleached rayon flock strong enough to last out a ten-days' exhibition.

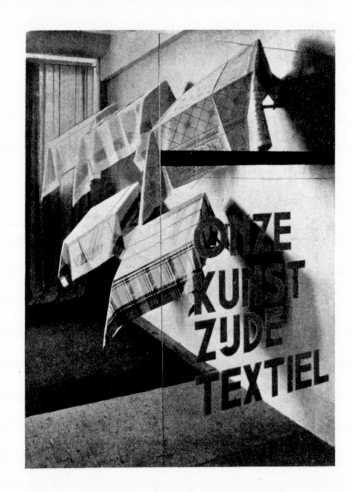

Moholy's work appeared once again in the pages of the *Architects' Journal* in May 1935, this time an eclectic textile display he had designed for a trade fair in Utrecht. That same month he left Amsterdam for London, arriving with no financial means to support himself and speaking very little English. He and Sibyl were immediately given hospitality at the Lawn Road Flats by Jack Pritchard, who later recalled Moholy's 'magnificent, infectious grin'.[5] Pritchard, a key figure in British inter-war design, and marketing manager of the Estonian plywood company Venesta, had commissioned the pioneering Lawn Road Flats from the Canadian architect (and MARS member) Wells Coates; the building had soon become an oasis for refugees from central Europe and a hub for modern artists and architects. The architect and designer Marcel Breuer – another Bauhaus émigré – soon followed Gropius and Moholy-Nagy to London, and Pritchard strove to find work and opportunities for all three of them during their stay in the country.

Left:
Architects' Journal, 9 May 1935, p.715

Right:
Jack Pritchard's penthouse in the Isokon Flats, Lawn Road, London, with Moholy-Nagy's *Nude Negative* (1920) displayed on the left

7, FARM WALK
HAMPSTEAD GARDEN SUBURB,
London, N.W. 11.

8th. September 1935

(Speedwell 8847)

Dear Mrs. Goldfinger,

We should be very pleased to see you and Mr. Goldfinger at Friday, 13th. of September for a little after - dinner - chatter. —

The next way to find our house, is to go the Finchley - Road from Golders Green tubestation straight uphill in the Finchley direction then, on the right hand, after a short mile the Hampstead Way is going acros.

The first street from the Hampstead way on the right hand is our Farm Walk, where we are the first house.

I hope so much to see you and your husband on Friday.

With our best regards

Yours sincerely

Sibyl Moholy-Nagy

Left and right:
Letter from Sibyl Moholy-Nagy to Ursula
Goldfinger, 8 September 1935

After a few months the Moholy-Nagys moved to a house
in West Hampstead, and they were soon able to renew
old acquaintances and to establish new friendships and
professional contacts among fellow émigrés and locals.
Collaborations with architects were particularly appealing
to Moholy, and shortly after his arrival he was offered
work on two projects by Ernö Goldfinger, although neither
materialised. The first was a documentary film of the
architect's prospective buildings, which Moholy costed
for him; the second was a photo-mural for a hair salon in
nearby Golders Green that Goldfinger was in the process
of designing. This project eventually turned into a lingerie
shop and the mural proposed by Moholy was never
realised. Despite his disappointment, he would soon have
the opportunity to explore both types of work elsewhere.

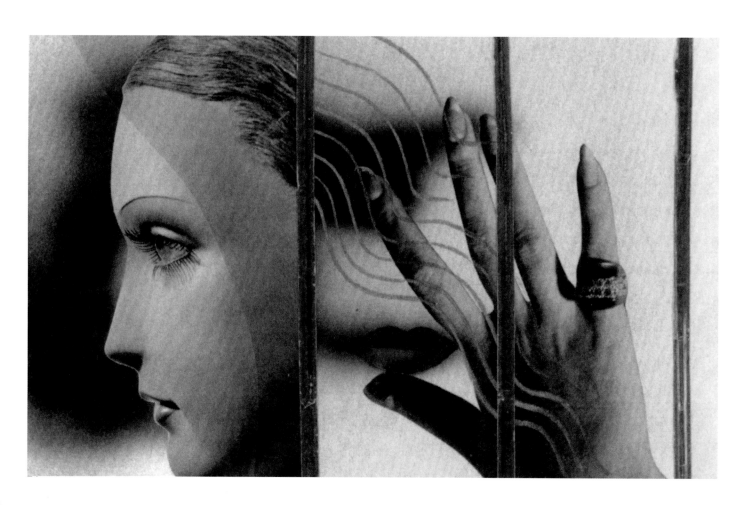

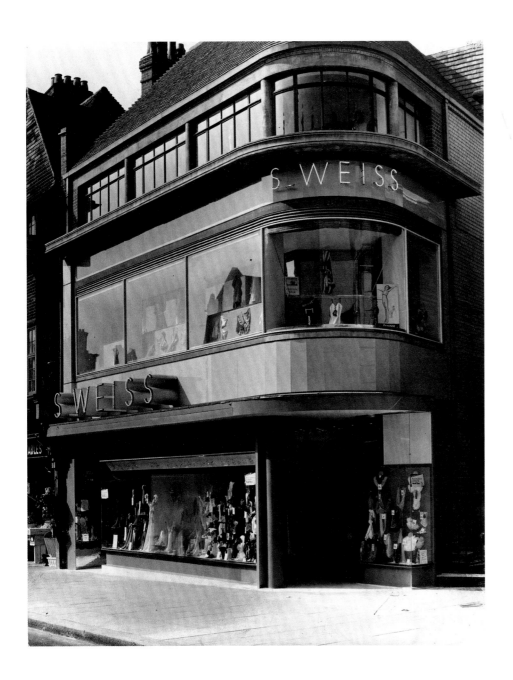

Above:
S. Weiss lingerie shop, Golders Green, London, by
Ernö Goldfinger (photograph: Herbert Felton, 1936)

Left:
Design for photo-mural for hair salon in Golders
Green, London (László Moholy-Nagy, 1935)

9 OCT REC'D

PALLAS studio

167, STRAND, LONDON, W.C.2, TEMPLE BAR 5671, TEL. INTERNATEX

8th October, 1935.

E.Goldfinger, Esq.,
7, Bedford Square,
London, W.C.1.

Dear Goldfinger,

I have prepared an estimate for the
documentary architectural film dealing with the buildings
you are at present constructing.

This estimate comprises the work of one
year only, and could be slightly reduced in the cost of
materials if an exact manuscript were available.

Yours sincerely,

L. Moholy-Nagy

167, STRAND, LONDON, W.C.2. TEMPLE BAR 5671, TEL. INTERNATEX

8th October, 1935.

E.Goldfinger, Esq.,
7, Bedford Square,
London, W.C.1.

E S T I M A T E.

	£. s. d.
Shooting once a week at 15 guineas	780 0 0
One Sinclair ~~box~~ various lenses, filter, or loan £5 per week	250 0 0
One Kinamo loan	50 0 0
Two Tripods	20 0 0
Material, about 60,000 ft. (2d. per ft.)	500 0 0
Developing and Printing (3d. developing, 1d. copy)	500 0 0
Synchronising and Music	200 0 0
Manuscript and Direction	500 0 0
	£2800. 0. 0d.

- - - - - - - - -

Left and above:
Letter from László Moholy-Nagy to Ernö Goldfinger,
with an estimate of costs for a documentary on
Goldfinger's buildings, 8 October 1935

27

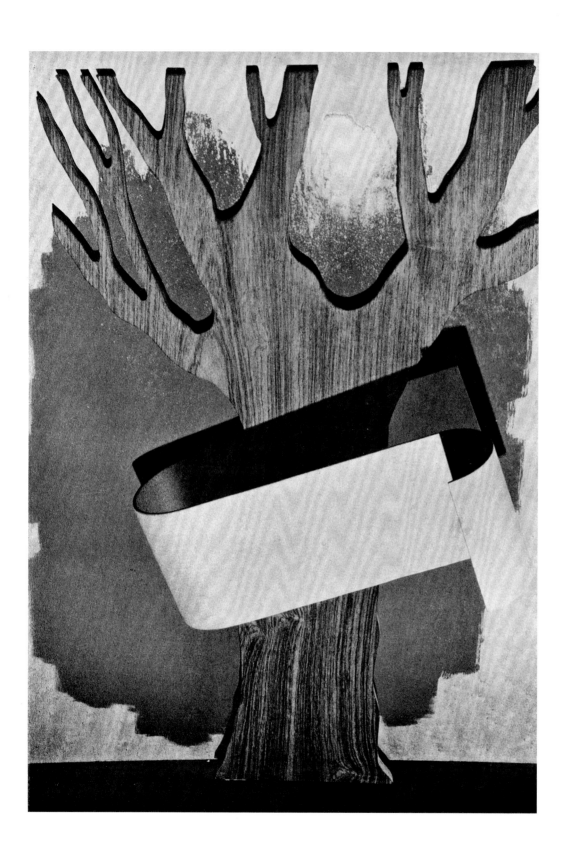

Above:
Advert for Venesta plywood, *Architectural Review*,
February 1936, after p.80 (artwork: László Moholy-Nagy)

Pallas Studio had an office on the Strand, and it is here that Moholy started his professional career in Britain, 'shocking printers with his unorthodox ideas on type and layout and delighting the unspoiled English office help with candy and flowers which he never forgot to buy', according to Sibyl. It was through the publicity agency working with *International Textiles* that Moholy started receiving several offers of work as graphic designer, which he accepted with gratitude and shared with fellow Hungarian György Kepes, who had previously worked with him in Berlin and followed him to London. Sibyl grew 'used to the fact that Moholy was gone all day – swallowed by London, unreachable because he worked in many different places'.[6] He designed advertising material for Imperial Airways, posters for London Transport – remarkable not only for their graphic style but also because they focused on the technical aspects of the underground system, unlike others produced at that time – and brochures for the Isokon furniture company established by Jack Pritchard, who in addition asked him to create an advert for Venesta plywood to be published in the *Architectural Review*.

"The brief was simple: to indicate that Venesta plywood was both rigid and flexible, and to avoid any emphasis on the technical quality or the company's policy. He worked fast; at first it seemed to me that he was too facile, but I soon realised that his speed was due to his speed of understanding and execution at the same time – analysis and synthesis almost in one operation. The result was a picture of a stylized tree of thick plywood, wrapped round with a sheet of very thin plywood by way of contrast. [...] The whole effect was good [...]"

Jack Pritchard, *View from a Long Chair*[7]

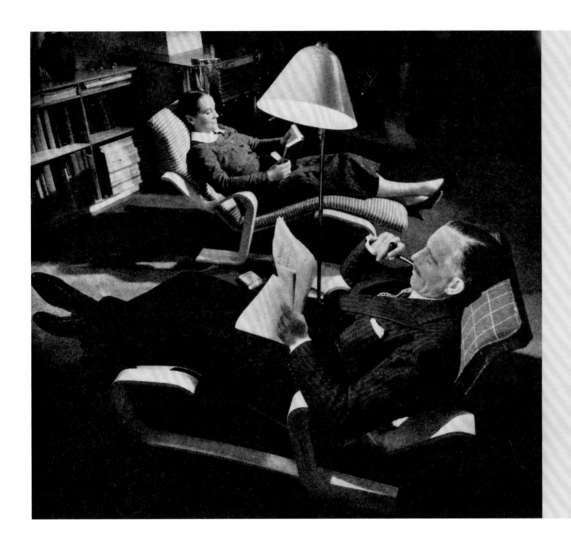

The ISOKON LONG CHAIR is light and well balanced. It can be moved and lifted easily (even by a child). It offers, with its surprising mobility, new ways of arrangements, even in a limited space.

You can sit and turn sideways by a fire instead of burning your feet while your body freezes. Two can be placed side by side but facing each other—an ideal arrangement for a quiet talk, or for tea. They can be moved to the window to get the sunshine.

You cannot do any of these things with heavy, old-fashioned chairs.

*TYPOGRAPHY BY MOHOLY-NAGY
PRINTED BY LUND HUMPHRIES*

Left and above:
The two sides of a brochure for Isokon furniture
(design: László Moholy-Nagy, 1935–36)

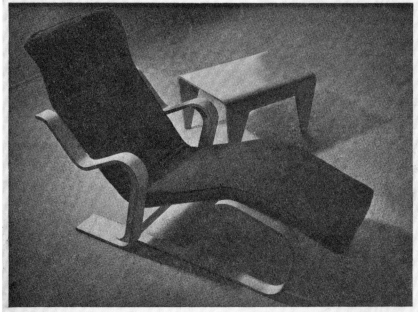

Left:
Brochure for Isokon furniture
(design: László Moholy-Nagy, 1935–36)

Right:
Poster designed for London Transport
(design: László Moholy-Nagy, 1936–37)

Overleaf:
Posters designed for London Transport
(design: László Moholy-Nagy, 1936–37)

YOUR FARE FROM THIS STATION

2 TO

Burnt Oak
Golders Green

SOON IN THE TRAIN BY
ESCALATOR

1 The level platform

2 Beginning to go down

3 Going down

Each step of the escalator is a separate four-wheeled truck. The rear pair of wheels runs on one track, the front pair on another.

The trucks are driven by an endless chain to which they are all attached.

When the track for the back wheels is above that for the front wheels, the steps form a level platform (1).

This level platform is changed into a moving staircase by the tracks being gradually brought level with each other as they turn down the slope (2 and 3).

m·n

WATERLOW & SONS LTD., LONDON & DUNSTABLE

QUICKLY AWAY, THANKS TO
DOORS
PNEUMATIC

The doors,
which are edged with
rubber, are kept closed by
air-engine arms, one for each door.

The arms engage in slots in the doors, which open
when the arms swing round. The doors are
held open by the arms. The signal
to start cannot be given while
the doors are open.

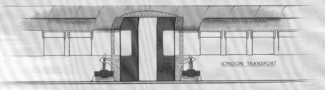

LONDON TRANSPORT

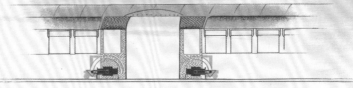

moholy-nagy

32-87-1500

WATERLOW & SONS LTD., LONDON & DUNSTABLE.

He also designed a number of exhibitions on aviation for Imperial Airways: the first at the Science Museum – in collaboration with Raymond McGrath – which opened in December 1935; the second at Charing Cross underground station in the summer of 1936, and finally a mobile exhibition that toured British cities in a railway car in 1937. All these projects embodied a new phase in Moholy-Nagy's graphic work that was partly influenced by his British environment and the work of designers such as McKnight Kauffer and Ashley Havinden. Havinden was a great admirer of Moholy-Nagy, whom he had met through the furniture designer John Duncan Miller. According to Havinden, 'abstract painters like Mondrian, Ben Nicholson and Moholy-Nagy have opened up new possibilities in spatial expression, the study of which should be of inestimable value, particularly to the lay-out man and typographer'.[8] He secured Moholy his most profitable employment during his stay in England:

a part-time consultancy for menswear store Simpson's, whose modern new premises, designed by Joseph Emberton, opened on Piccadilly in 1936. Havinden himself was responsible for the company's brand image, while Moholy oversaw the store displays together with Kepes. Moholy was excited by this opportunity to design in three dimensions once again, and in an area to which he had not previously applied his talent, but which was clearly of interest to him (in 1928 he had set a project for his Bauhaus students to design the layout of a modern department store selling clothes). He experimented with Rhodoid, a new transparent plastic material, in the mannequins and price tags, designed innovative plywood screens with cut-outs and brightly coloured brochures for mail adverts – in collaboration with Havinden – and proposed the installation of glass-encased lifts (not realised due to lack of time) to allow the customers a view of all the displays while moving up and down the store.

A letter sent to Emberton by the owner, Alec Simpson, reveals that Moholy had also suggested a novel idea for departmental signage based on symbols. For the store's opening he created a special window display – a still life of men's fashion, as described by David Wainwright in his book on Simpson's: 'It was like a stage-set, colourful and vigorous, and wholly new and original in the world of men's wear in 1936.'[9] In its first month the store also housed an exhibition concerning aviation on the top floor, designed by Moholy and complemented by the inclusion of three small aircraft, which received widespread publicity. Surprisingly, neither the *Architectural Review* nor the *Architects' Journal* highlighted the Bauhaus émigré's contribution to the store's interiors, whereas the *Architect & Building News* declared that 'the genius of Prof. Moholy-Nagy presides over the disposition of the goods'.[10]

Left:
Brochure for Imperial Airways
(design: László Moholy-Nagy, 1936)

Below:
Simpson's shop windows in *Architectural Design*, June 1936, p.274 (window display design: László Moholy-Nagy)

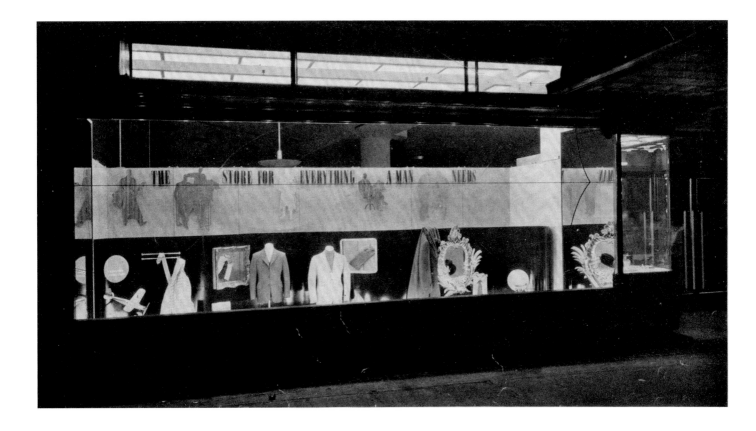

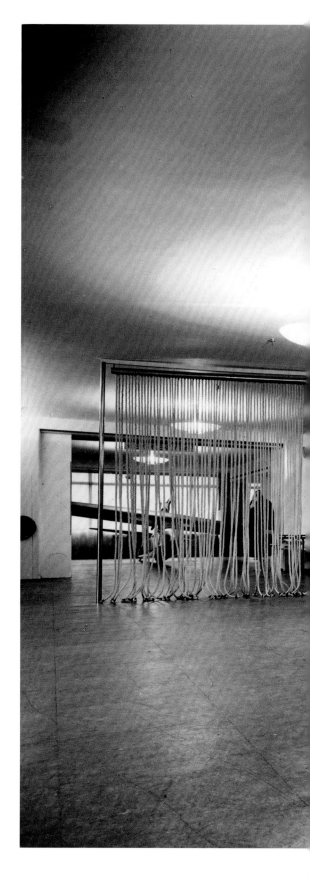

Top floor display on aviation, Simpson's, Piccadilly,
London (display design: László Moholy-Nagy,
photograph: Sydney Newbery, 1936)

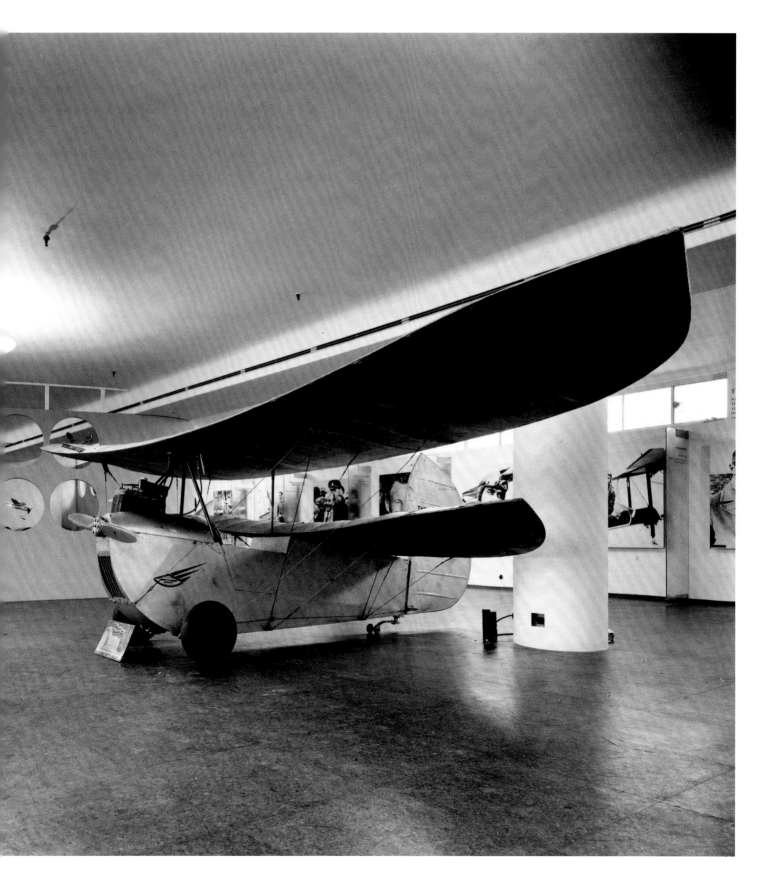

In 1936 the Museum of Modern Art in New York approached Moholy to commission a film on the new structures designed for London Zoo by Berthold Lubetkin and his practice Tecton, as part of an exhibition on modern architecture in England organised in collaboration with the Department of Architecture at Harvard University. The resulting documentary, *New Architecture and the London Zoo*, filmed by Moholy both in London and at the Zoo's branch in Whipsnade, was later deemed too naturalistic by Lubetkin, and the architect reported that 'Moholy wanted simply to record, and maintained that the world was full of shapes, textures and movements'.[11] Moholy had already used his experience as a film-maker in the documentary *Lobsters*, inspired by John Grierson's work with the GPO propaganda film unit. Centred on the fishing community of the Sussex coast, the film alternated standard documentary camera techniques with more unusual approaches typical of his earlier work, such as oblique viewpoints, close-ups, repetitions and an emphasis on geometric forms.

Right:
Models for a future city in *Things to Come*
(model design: László Moholy-Nagy, 1935)

His other involvement in film during his time in Britain was a commission received for the science fiction feature *Things to Come* (1936), adapted from a novel by H.G. Wells and produced by another fellow Hungarian, movie mogul Alexander Korda. Korda (or his collaborator Ned Mann) had been impressed by Moholy's short abstract film *Light Display: Black, White, Grey* of 1930, and was looking for a visionary artist to design the sets and special effects that would introduce his city of the future, having already rejected Fernand Léger's proposal and been turned down by Le Corbusier. Moholy enthusiastically accepted and worked with the studio's craftsmen to create his own utopian city, which was light and transparent, and populated by skyscrapers clearly inspired by Mies van der Rohe's famous project of 1922. The models created were an opportunity for Moholy to experiment with Rhodoid for the first time, an experience that would translate into the Rhodoid-on-plywood painted reliefs of 1936 and later into the Plexiglas sculptures of his American period. He also worked with a special effects camera assistant to create experimental sequences that were strikingly abstract and once again based on the play of light. To his great disappointment, all of his work, with the exception of a few seconds of his special effects, was discarded – perhaps being considered too avant-garde – and the sets were eventually designed by Korda's brother (and Moholy's acquaintance) Vincent, while Ned Mann was responsible for the special effects.

More successful were the photographic commissions he received from publisher John Miles to illustrate three books on quintessentially British subjects, for which Moholy took hundreds of images with his trusted Leica. He had been recommended to the publisher by another MARS member and assistant editor of the *Architectural Review*, John Betjeman, whose wife Penelope had met Moholy and been photographed by him in Berlin in 1933. For Moholy, the thematic series had become the logical culmination of conventional photography, an 'effective technique approximating to that of the film'.[12] The photographs taken for the first of the three books, *The Street Markets of London* (1936), are predominantly documentary in character and demonstrate Moholy's keen interest in getting close to and understanding his subjects. Those taken for the second volume, *An Eton Portrait* (1937), subtly convey an outsider's view of a very British institution; they arguably represent the pinnacle of his photographic work in Britain, alternating observations of the daily life of the school with poetic scenes. The book's author, ex-Etonian Bernard Fergusson, knew nothing about Moholy, but warmed to him very quickly.

"I was warned [by the publisher] that I would find his technique totally different from anything I had ever seen before; that he was not primarily a photographer, but an artist with revolutionary ideas about contrast: contrast between light and shade, movement and stillness. [...] Moholy was a dear, friendly, twinkling man, but so untidy and eccentric as to be a continuous source of embarrassment to the very conventional young Old Etonian soldier that I then was."

Bernard Fergusson, 'A Hungarian at Eton and Oxford'[13]

Fergusson spent three days on location with Moholy, comparing notes over a cup of tea at the end of each day, when the artist would often emphasise, 'It is all [a] question of light and shade!'[14] *Eton Portrait* was very well received – especially the photographs, a selection of which were reproduced in *Time* magazine – and won an award as one of the best-produced books of the year.

Below:
'A Field Match' in *Eton Portrait*, 1937
(photograph: László Moholy-Nagy)

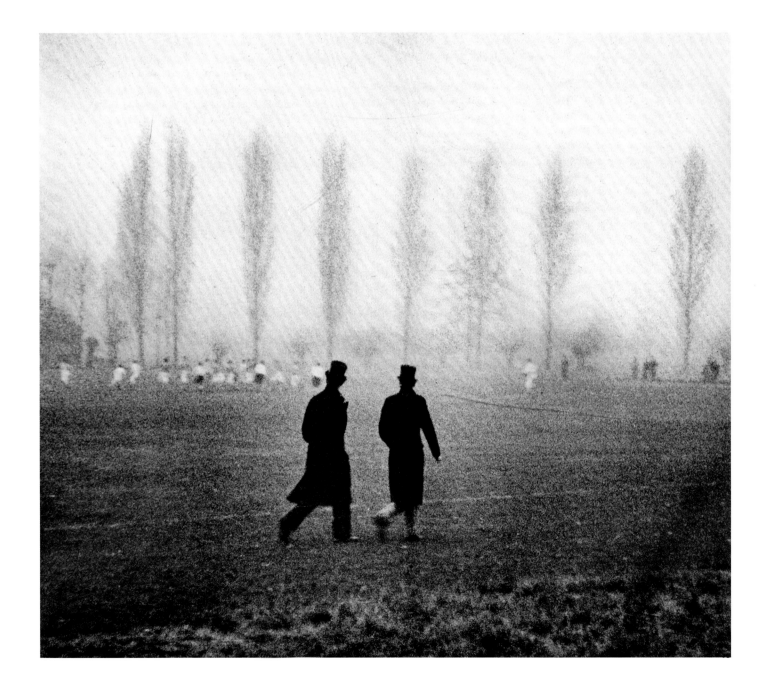

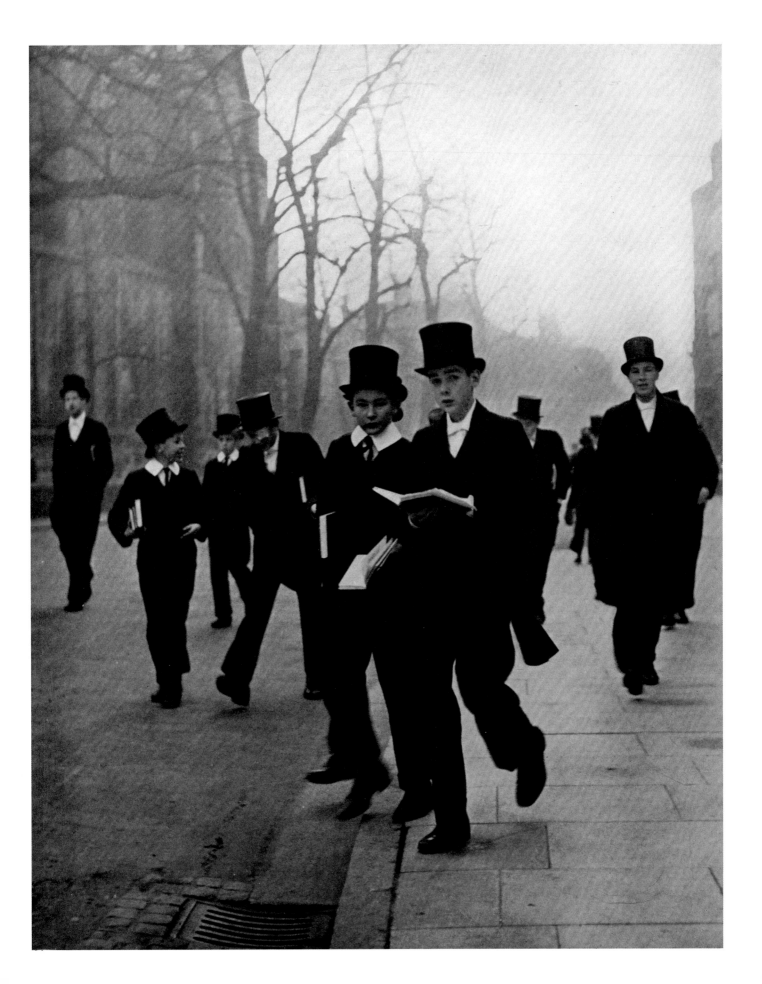

Left:
'Between Chapel and School'

Right:
'Waiting for their owners'

Below:
'Fourth of June'

All in *Eton Portrait*, 1937
(photographs: László Moholy-Nagy)

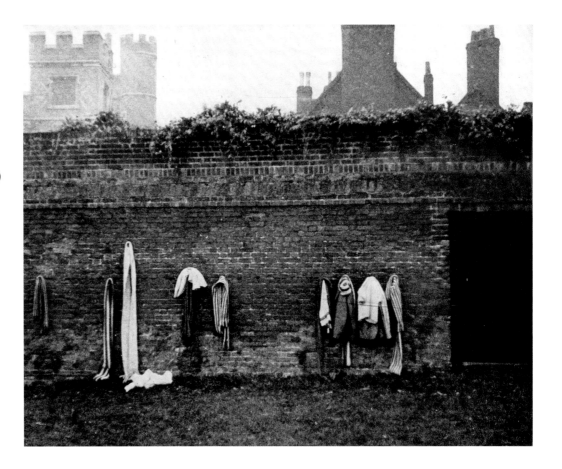

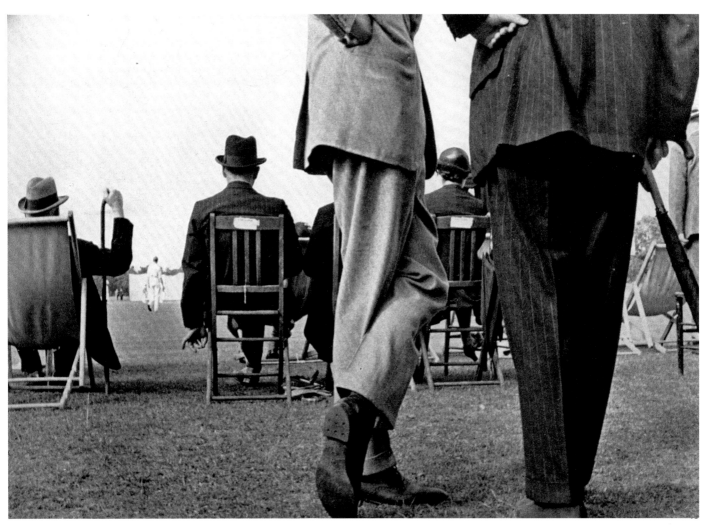

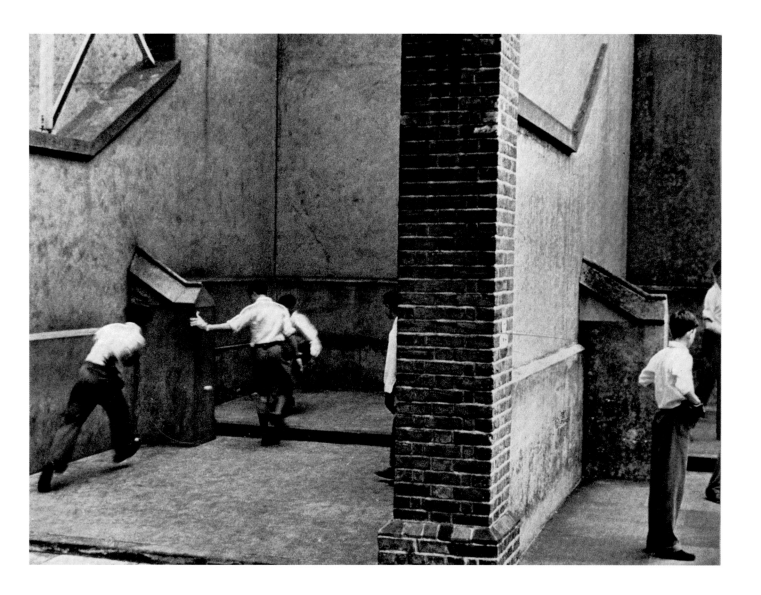

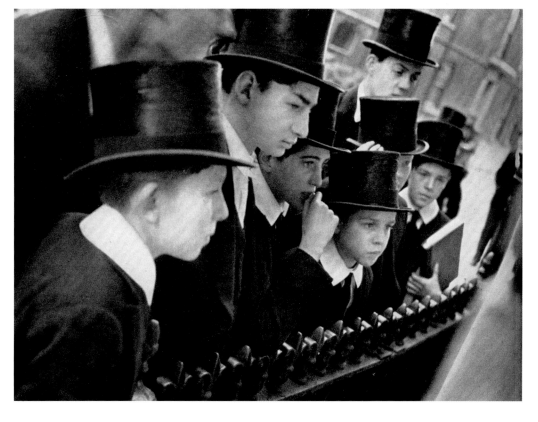

Above:
'Fives'

Left:
'Spottiswoode's window'

Right:
'Practising for Certificate A'

All in *Eton Portrait*, 1937
(photographs: László Moholy-Nagy)

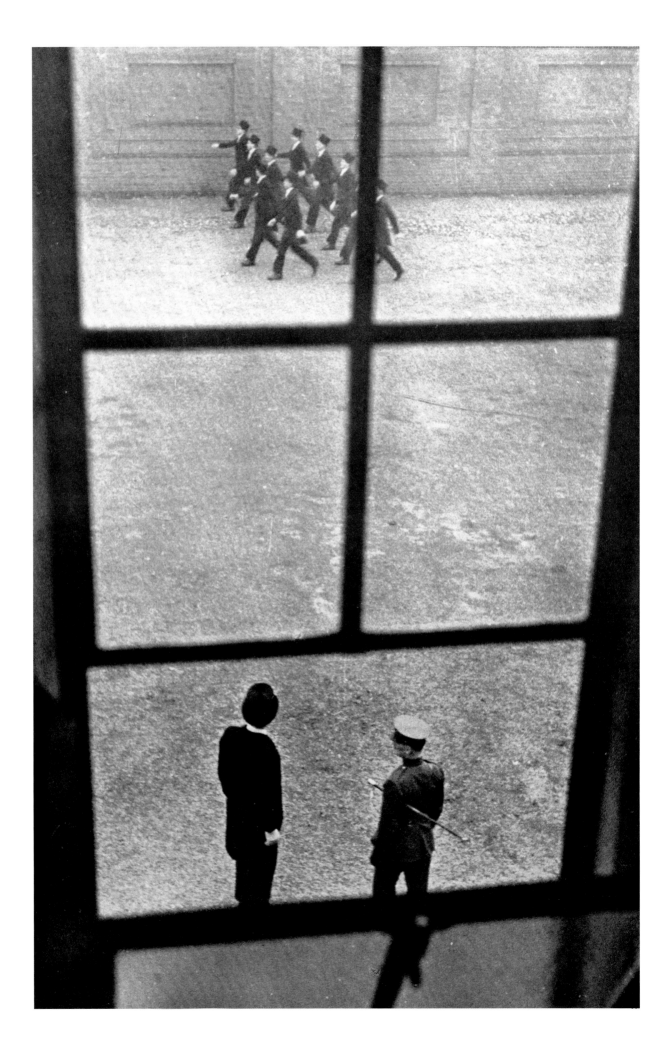

In *An Oxford University Chest* (1938), written by Betjeman himself, the emphasis shifts towards the architectural heritage of the city, but not to the exclusion of more spontaneous moments or the occasional unconventional composition. Penelope Betjeman accompanied Moholy around the city in search of the right viewpoints, and later recalled: 'Moholy was tremendous fun to be with and full of enthusiasm for the things that interested him, especially architecture; and he was fascinated by Oxford and we greatly enjoyed our scramble over the roofs.'[15] Even if the modest reproduction quality in the book does not entirely do justice to the photographs, she later referred to them as 'among the best ever taken in Oxford'. John Betjeman, who remembers Moholy as 'a huge man with a constant smile', was also impressed by the artist's efforts.

Top right:
'A Broad Street stationery shop'

Bottom right:
The gates of Trinity College

Both in *An Oxford University Chest*, 1938
(photographs: László Moholy-Nagy)

"The result of Moholy's clickings was hundreds of little prints measuring about one square inch, and from these he selected those which were to be enlarged. That was where his genius lay. He knew just which to choose, showing the beauty of crumbling stone, the crispness of carved eighteenth-century urns, and members of the public who were quite unconscious they were being photographed."

John Betjeman, 'A Hungarian at Eton and Oxford'[16]

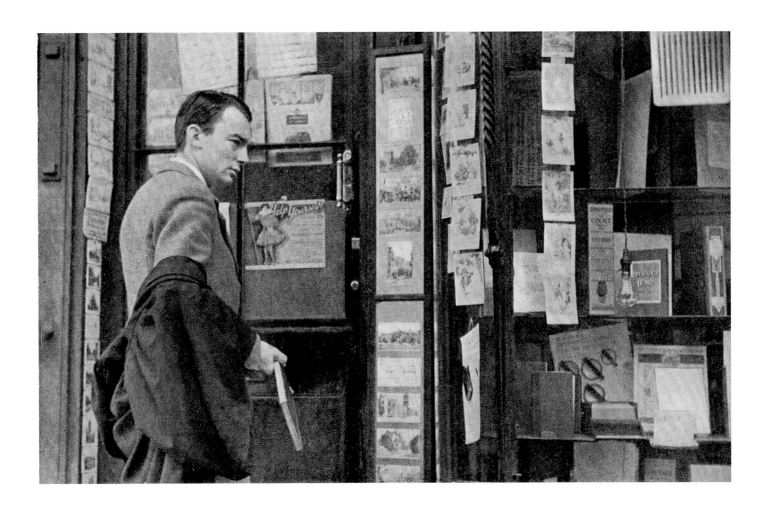

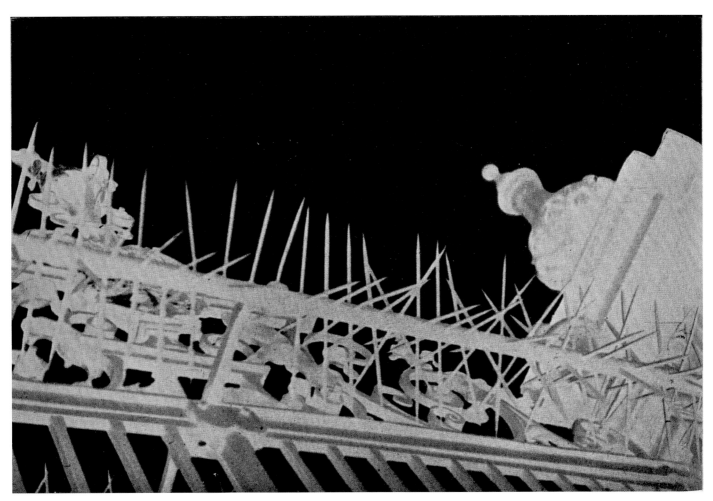

Clockwise from top left:
St Mary the Virgin's Church; 'Dr Frewen
in the Bodleian'; 'An All Souls Quadrangle
from the Radcliffe Camera'; Untitled

All in *An Oxford University Chest*, 1938
(photographs: László Moholy-Nagy)

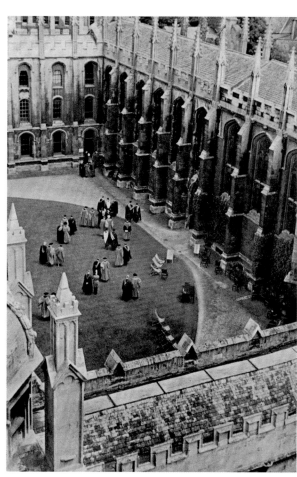

Top:
'Jericho'

Bottom:
'The Cherwell'

All in *An Oxford University Chest*, 1938
(photographs: László Moholy-Nagy)

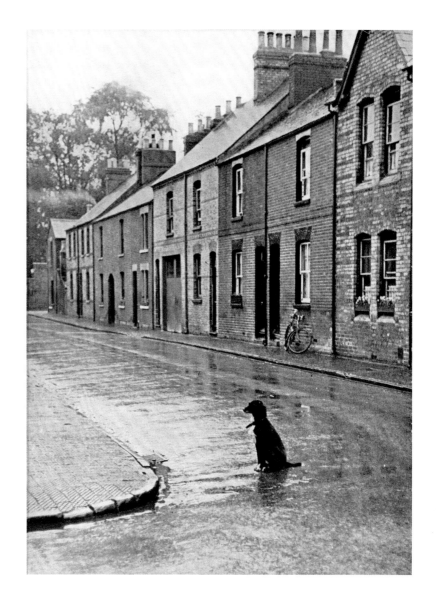

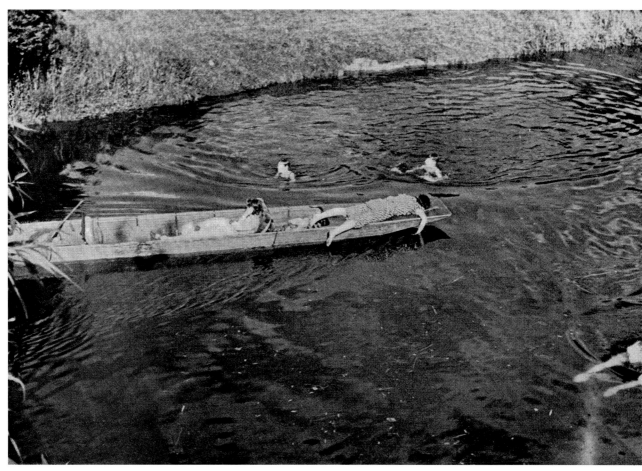

I

THE ENGLISH AT THE SEASIDE

By Osbert Lancaster

Britannia rules the waves! At the time when this proud boast was first set to music, in the middle of the eighteenth century, it is highly improbable that one in a thousand of the loyal Britons who joined so heartily in the chorus had the remotest idea of what a wave actually looked like. Of the whole population of these islands the only people that were likely ever to come in view of the sea were the dwellers on the coast, those members of the mercantile fraternity and His Majesty's forces whom commerce and war compelled to embark for foreign parts, and a small section of the aristocracy who crossed the channel in search of pleasure and enlightenment. The sole visit to the seaside that the average citizen was likely to make was one in company with the press-gang. The reason for this state of affairs was complex but perfectly sound : the vast majority had neither the means nor—more important still in the days before the annual holiday had been dreamt of—the leisure to travel, while their betters on the other hand, although by no means averse to travel, were not willing lightly to expose themselves to its perils and discomforts. When they did set out on a journey they did so with a definite object in view, either pleasure or health, and until Dr. Russell made his revolutionary discovery in the sixties they saw small prospect of the sea providing either. However, the enterprising doctor soon showed them the error of their ways.

In the eighteenth century medicinal springs enjoyed that popularity among wealthy hypochondriacs that today is reserved for rays, and when the attention of the polite world was first drawn to the curative properties of sea water they flocked to Brighton, partly because it was the residence of the celebrated Russell himself and partly because Nature had neglected to provide any supply of sea-water within easier reach of London. The sea itself had for the new visitors precisely the same significance as the thermal springs at Bath ; it was not until much later that any virtues were conceded to it other than those presented by its medicinal properties, and the rapid success of Brighton as a pleasure resort was due to circumstances largely unconnected with its marine position.

Towards the close of the eighteenth century conditions of travel were rapidly improving

Equally successful and perhaps even more fulfilling was the commission he received from the *Architectural Review* to illustrate and design the layout for an article on the English seaside, to be published in the July 1936 issue of the magazine. This feature had been conceived to accompany an article on the De La Warr Pavilion in Bexhill, designed the previous year by Russian-born Serge Chermayeff with another high-profile émigré, German architect Eric Mendelsohn. Moholy visited several seaside resorts in the south-east with the *Review*'s editor, Jim Richards, who introduced him in his memoirs with a vivid description: 'His sparkling round spectacles and amiable grin gave him an air of bonhomie that quickly made him friends.' Richards adds: 'Moholy delighted in taking advantage of the latitude often accorded to foreigners – I suppose because they are believed to know no better – to behave inexplicably and more intrusively than would be permitted to an Englishman.'[17] Richards's impression is confirmed by Jack Pritchard's remark that 'Moholy had a wonderful way of using words as if in error or through not understanding the language – sometimes, I suspect, on purpose.'[18]

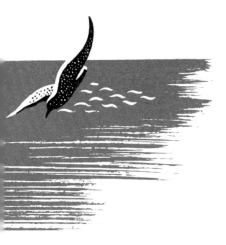

"I remember an instance of this at Bexhill-on-Sea, in the summer of 1936. [...] Moholy was wandering about with his camera. I went off on some other errand, and when we rejoined each other I asked if he had managed to get some pictures I knew he wanted, looking down on the crowds strolling along the sea-front. 'Oh yes,' he said pointing, 'I took them from the bathroom window of that house over there.' No one but an obvious foreigner, especially one with Moholy's engaging, slightly clownish manner, could have rung a private door-bell at Bexhill and talked himself with no difficulty into the owner's bathroom."

James Maude Richards, *Memoirs of an Unjust Fella*[19]

Bernard Fergusson recounts a similar episode occurring at Eton, when he had to rescue Moholy from the anger of a college functionary who objected to his intrusion.

Top left:
Architectural Review, July 1936, p.8

Next pages:
László Moholy-Nagy's photographs featured in 'Leisure at the Seaside', *Architectural Review*, July 1936

Bottom left and above:
Photo-drawing composites by László Moholy-Nagy featured in 'Leisure at the Seaside', *Architectural Review*, July 1936

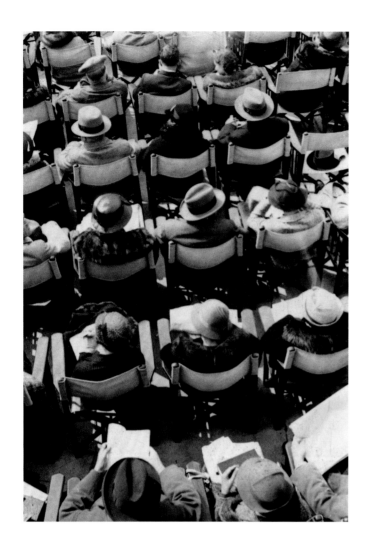

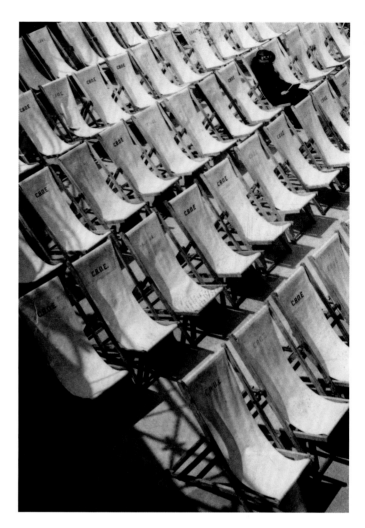

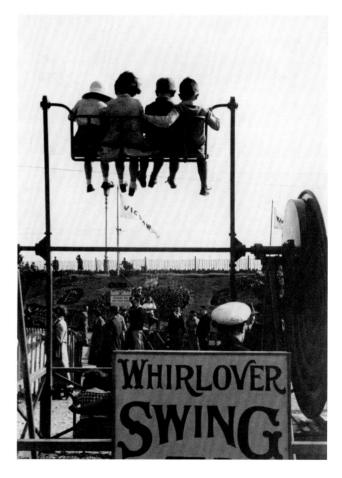

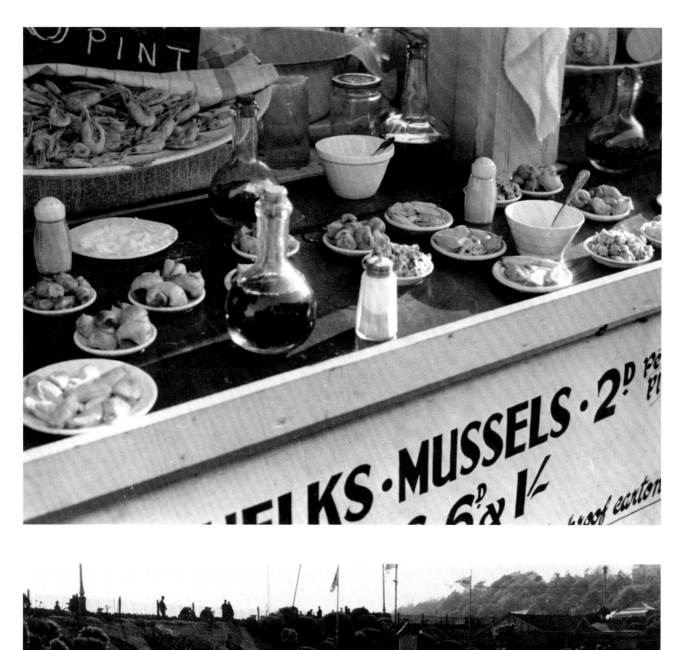

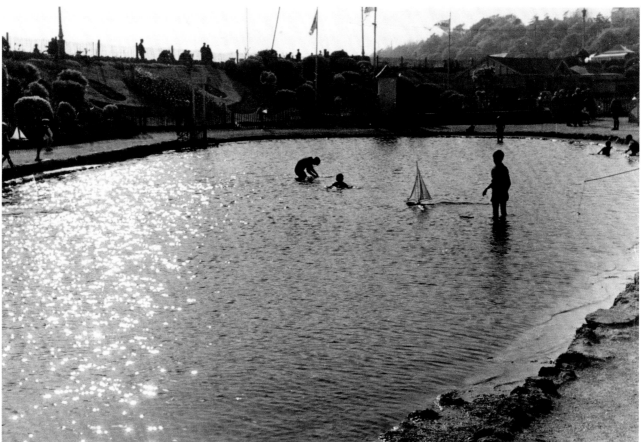

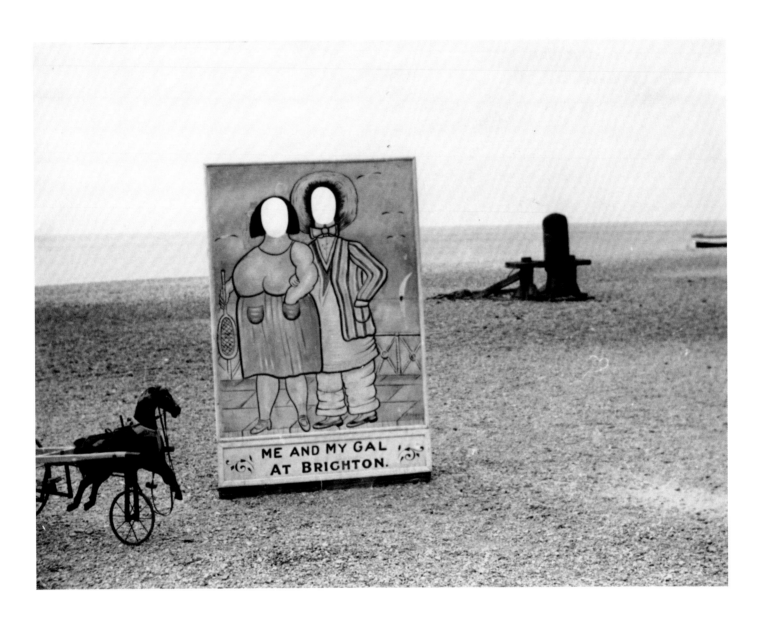

Above:
Photograph of Brighton beach by László
Moholy-Nagy, featured in 'Leisure at the
Seaside', *Architectural Review*, July 1936

Right:
Architectural Review, July 1936, p.11

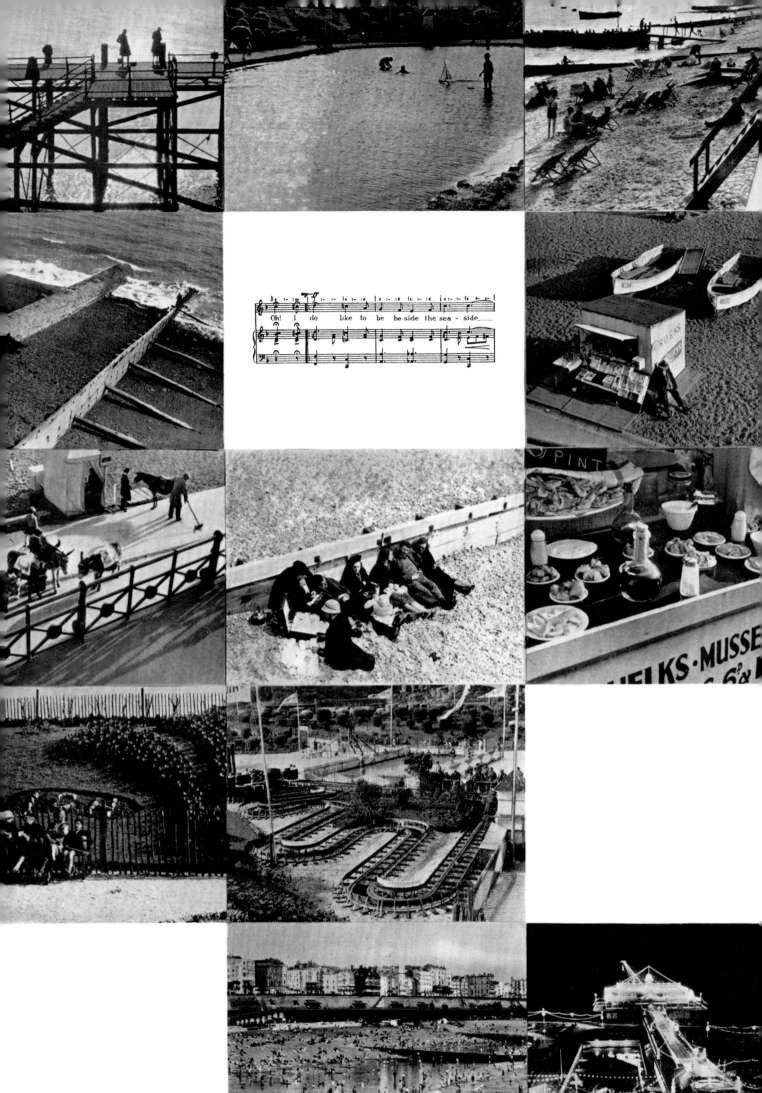

Oh! I do like to be be-side the sea - side........

Moholy also took photographs at Bexhill accompanied by Chermayeff, achieving striking results in capturing the details of the Pavilion's glass-encased spiral staircase. The layout of the whole piece playfully exploits Moholy's creativity through the use of splashes of colour, combinations of photography and graphics, and the special feature of a page with round cut-outs which, once overlaid on a page filled with photographs, creates a photomontage of sorts. Some of the recurring elements of Moholy's art are therefore present in this article, as well as others more typical of his British period; his appreciation of the whimsical and the surreal is also clearly evident in the photographs taken for this assignment, which again range from the purely documentary to artful observations of repetitive motifs. This article left a lasting impression on *Architectural Review* contributor Gordon Cullen, who soon after started to adopt Moholy's techniques of photo-drawing composites and photomontage. Although there are no records of direct collaboration between the two designers, Cullen paid homage to Moholy's influence on his own work in the cartoon 'Breuer and Moholy-Nagy leave for America', published by the *Architects' Journal* in January 1938.

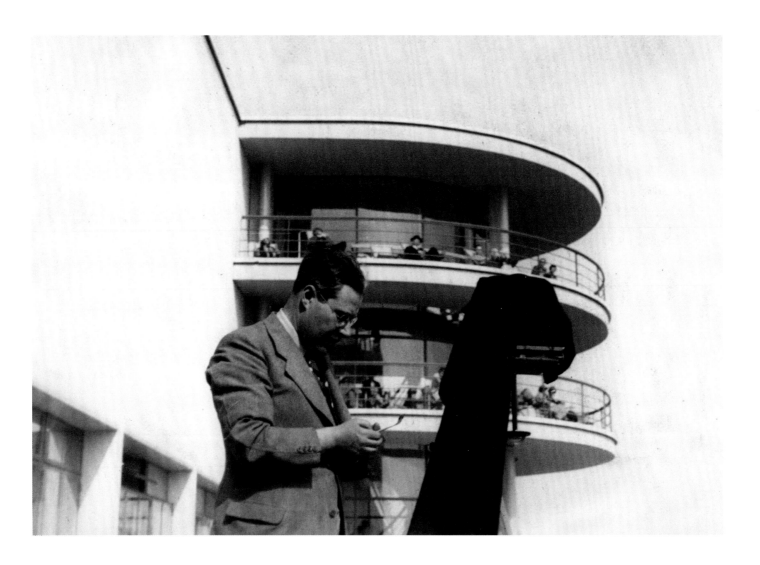

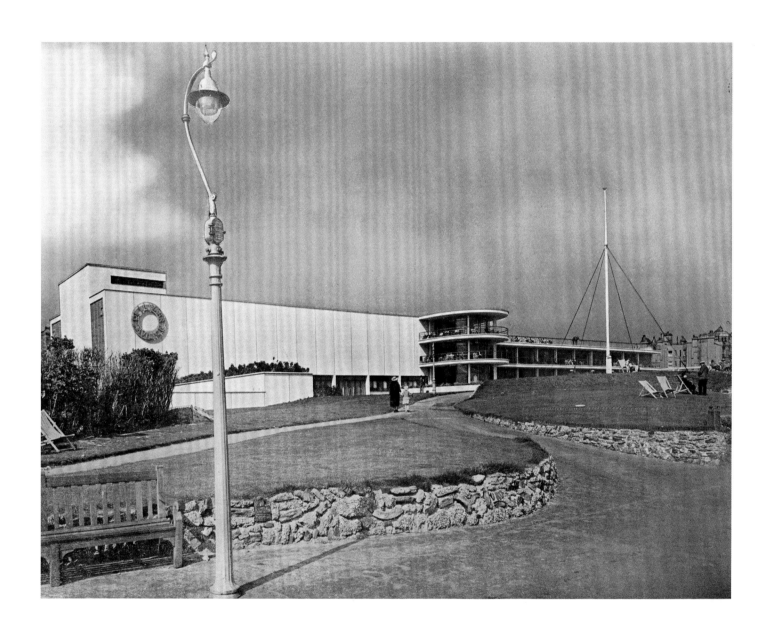

Left:
László Moholy-Nagy in front of the De La Warr
Pavilion, Bexhill-on-Sea, by Serge Chermayeff
and Erich Mendelsohn, 1935 (photograph:
Serge Chermayeff)

Above:
Illustration by László Moholy-Nagy from
'Leisure at the Seaside', *Architectural Review*,
July 1936, p.24

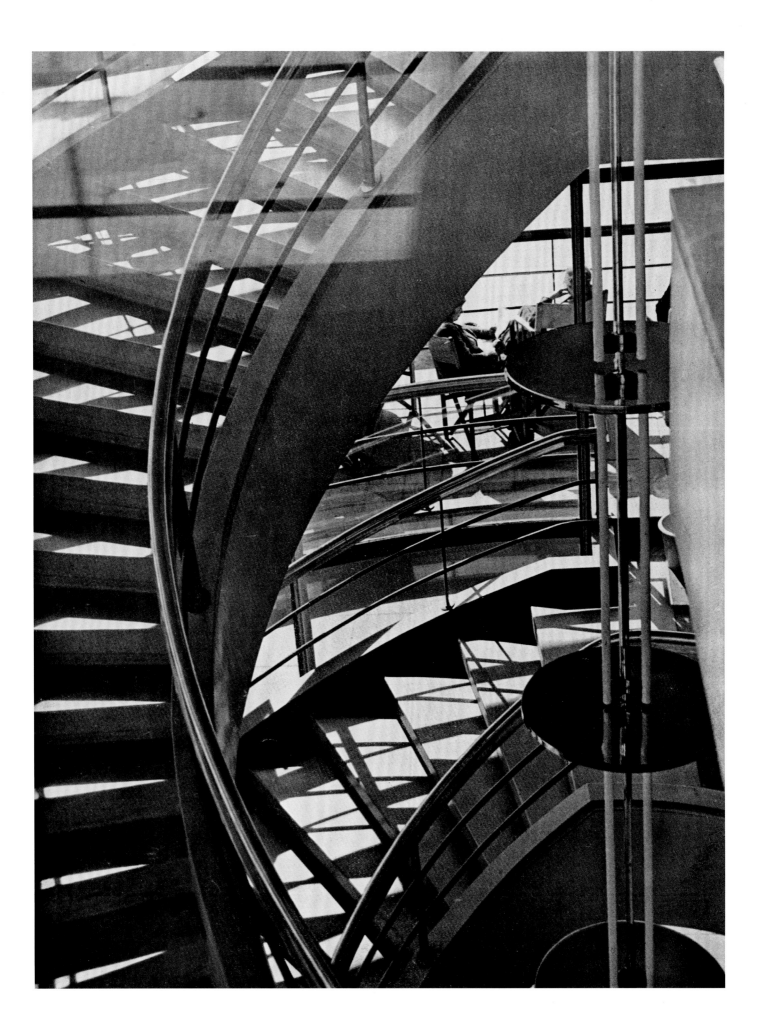

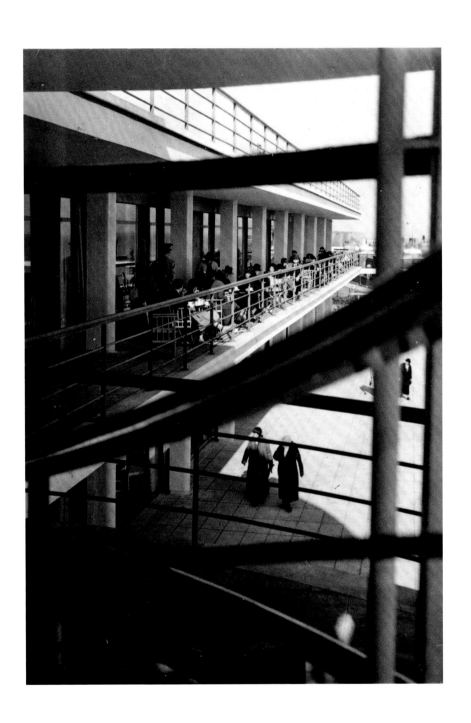

Left and above:
Photographs of De La Warr Pavilion by László
Moholy-Nagy featured in 'Leisure at the
Seaside', *Architectural Review*, July 1936

Aside from offers for commercial and editorial work, Moholy-Nagy was also in demand as a speaker and lecturer. In December 1936 he took part in a debate on Architecture in Relation to the Arts at the Royal Institute of British Architects, where he characteristically spoke of architecture in terms of the creation of space. Serge Chermayeff, who led the discussion, took part a few weeks later in a short television programme on a similar theme, in which he and John Piper discussed their admiration for Moholy's work. There were academic guest lectures at Oxford, Cambridge and the Liverpool School of Architecture. In early 1937 Moholy was invited by the young architect Leslie Martin, yet another member of MARS (which Moholy had himself joined), to lecture at

his newly founded School of Architecture in Hull. While staying with the Martins, Moholy took photographs of the city and its docks with his Leica during a walk with the architect, who recalled Moholy's spontaneous choice of subjects and his constant search for unusual viewpoints; only a contact sheet of this informal photo-shoot survives. Martin also included Moholy's work in *Circle*, his famous 'international survey of constructive art', which he edited with Ben Nicholson and Naum Gabo and published the same year. Moholy's influence on the architect was to prove long-lasting, especially with regard to architectural education; in turn, Martin became one of the most influential figures in British post-war architecture.

Good Health and Happiness Ahead
Laszlo and Sibyl Moholy-Nagy
7, Farm Walk, N.W.11

1937

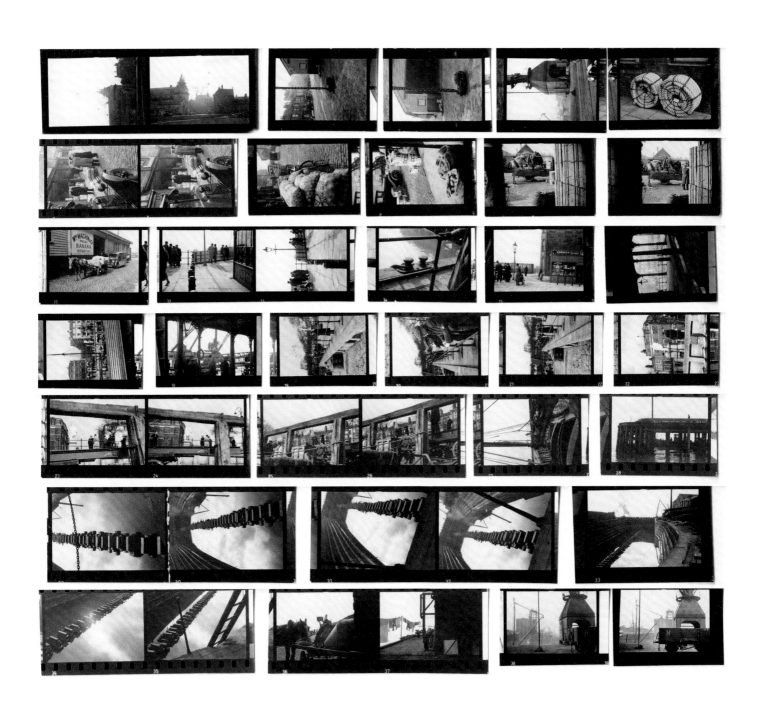

Left:
New Year's card sent by László and Sibyl
Moholy-Nagy to Leslie Martin, incorporating
photogram self-portrait of 1926

Above:
Contact sheet of photographs taken by
László Moholy-Nagy in Hull (1937)

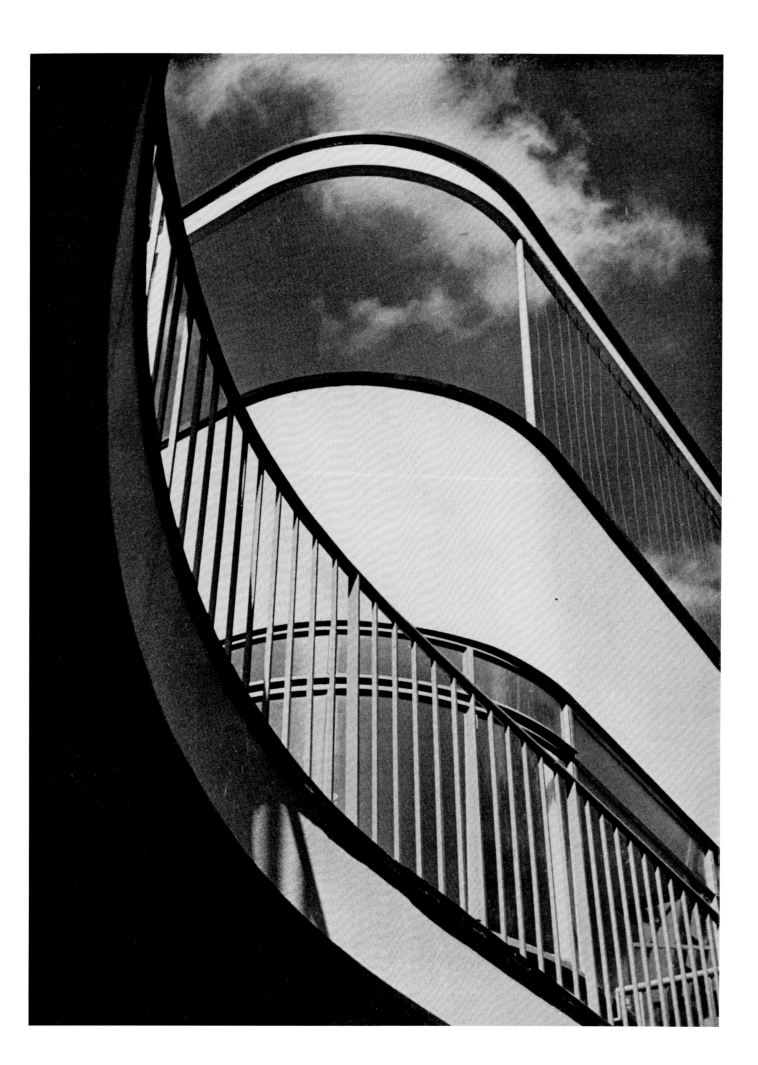

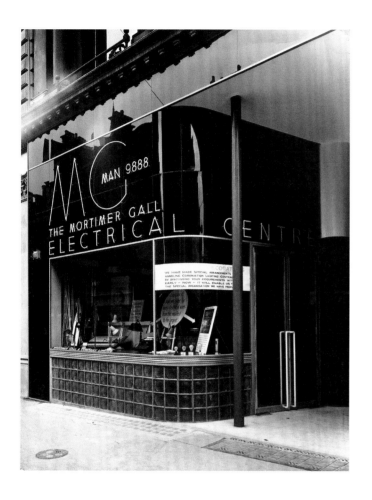

Among his collaborations with architects, there were a few opportunities to work with his ex-Bauhaus colleagues; Jack Pritchard employed all three of them at his Isokon company – Gropius as Controller of Design, Breuer to design its seminal plywood furniture and Moholy to create the related brochure. With Breuer, Moholy designed an exhibition pavilion for the Courtauld, and Gropius had attempted to obtain a theatrical commission for him at the progressive Dartington Hall school, which however did not come to fruition. Nonetheless, the work created by Gropius in partnership with Maxwell Fry had the scope to bring the two friends together.[20] Moholy unofficially photographed the house Gropius and Fry had designed for Benn Levy in Old Church Street, Chelsea, perhaps encouraged by the *Architectural Review*, which published an arresting full-page worm's-eye view detail of the exterior. He then collaborated with the two architects in the interiors of two showrooms for electrical appliances, creating outstanding photomurals for both, which channelled his past experience with photomontage and exhibition design. Working with Moholy had a transformative effect on Maxwell Fry, who developed a profound admiration for the Hungarian artist and acknowledged his influence on his own later work, something that was particularly evident in the sphere of exhibition design.

Left:
House for Benn Levy, Old Church Street,
London, by Walter Gropius and E. Maxwell Fry
(photograph: László Moholy-Nagy, 1936)

Above:
Mortimer Gall Electrical Centre, Cannon Street,
London, by Walter Gropius and E. Maxwell Fry
(photograph: Herbert Felton, 1937)

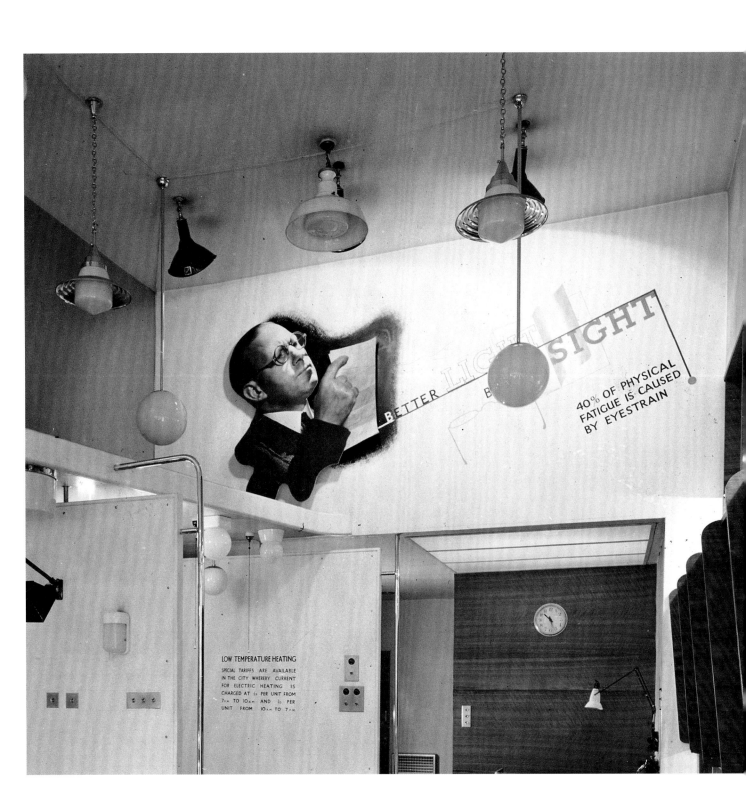

Above:
Photo-mural by László Moholy-Nagy in
Mortimer Gall Electrical Centre, Cannon Street,
London, by Walter Gropius and E. Maxwell Fry
(photograph: Herbert Felton, 1937)

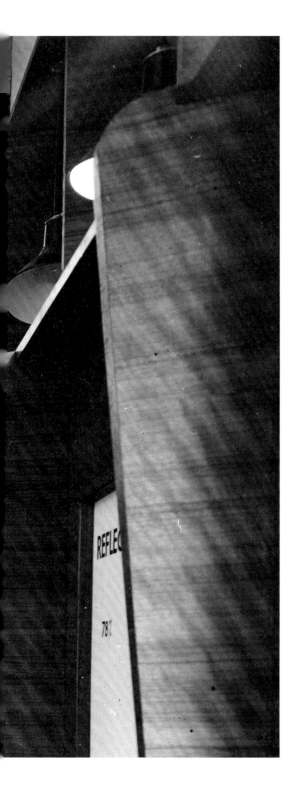

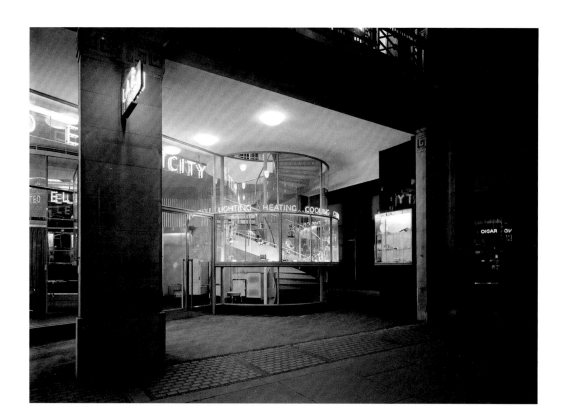

"… Moholy-Nagy, the gayest of men with so fertile an imagination that ideas tumbled out of him too fast to put to account. To walk with him along London streets gave one new eyes, O more, new senses for the sounds and sights, the irregularities and eccentricities of a too familiar townscape."

E. Maxwell Fry, *Autobiographical Sketches*[21]

Above:
Electricity showrooms, Regent Street, London, by Walter Gropius and E. Maxwell Fry (photograph: Dell & Wainwright, 1938)

Right:
Photo-mural by László Moholy-Nagy in electricity showrooms, Regent Street, London, by Walter Gropius and E. Maxwell Fry (photograph: Dell & Wainwright, 1938)

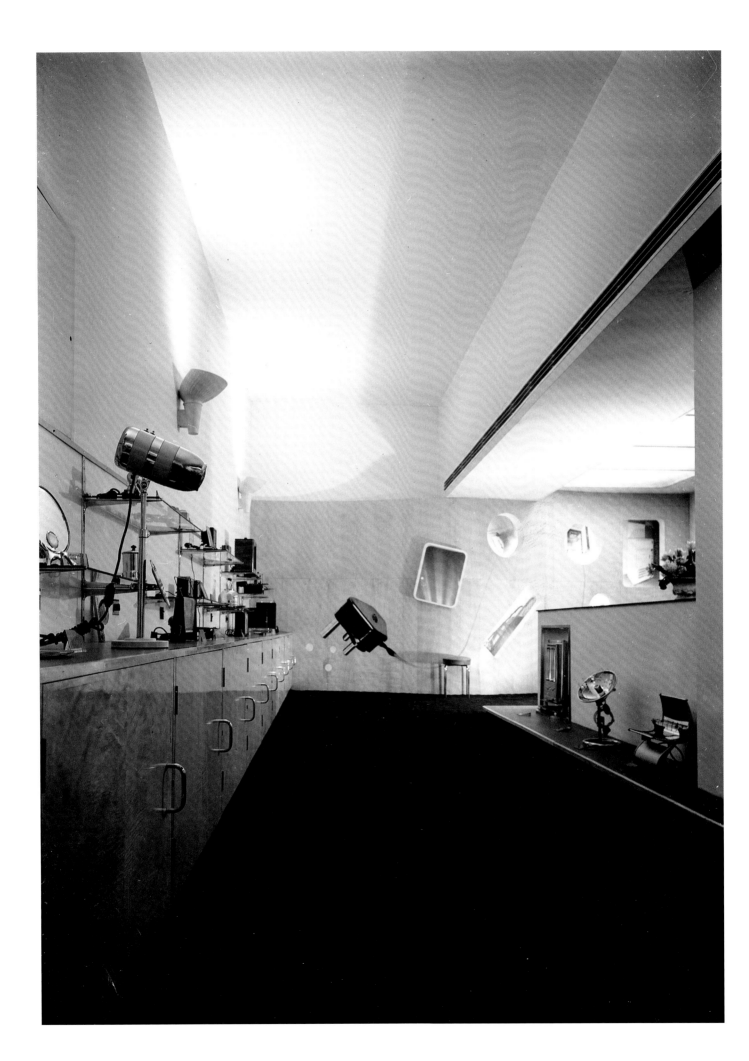

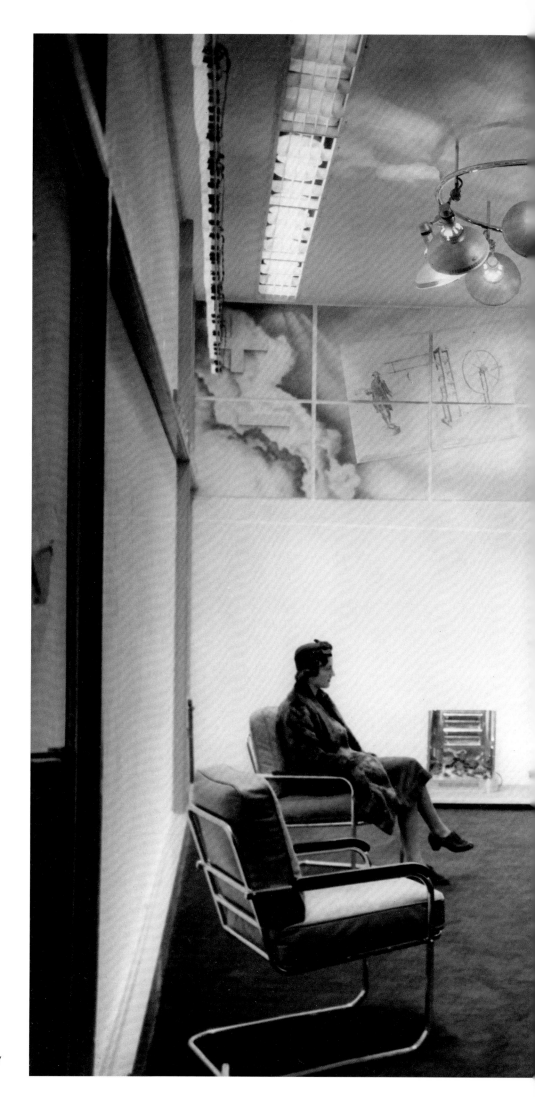

Right:
Photo-mural by László Moholy-Nagy in
electricity showrooms, Regent Street,
London, by Walter Gropius and E. Maxwell Fry
(photograph: Studio Briggs, 1938)

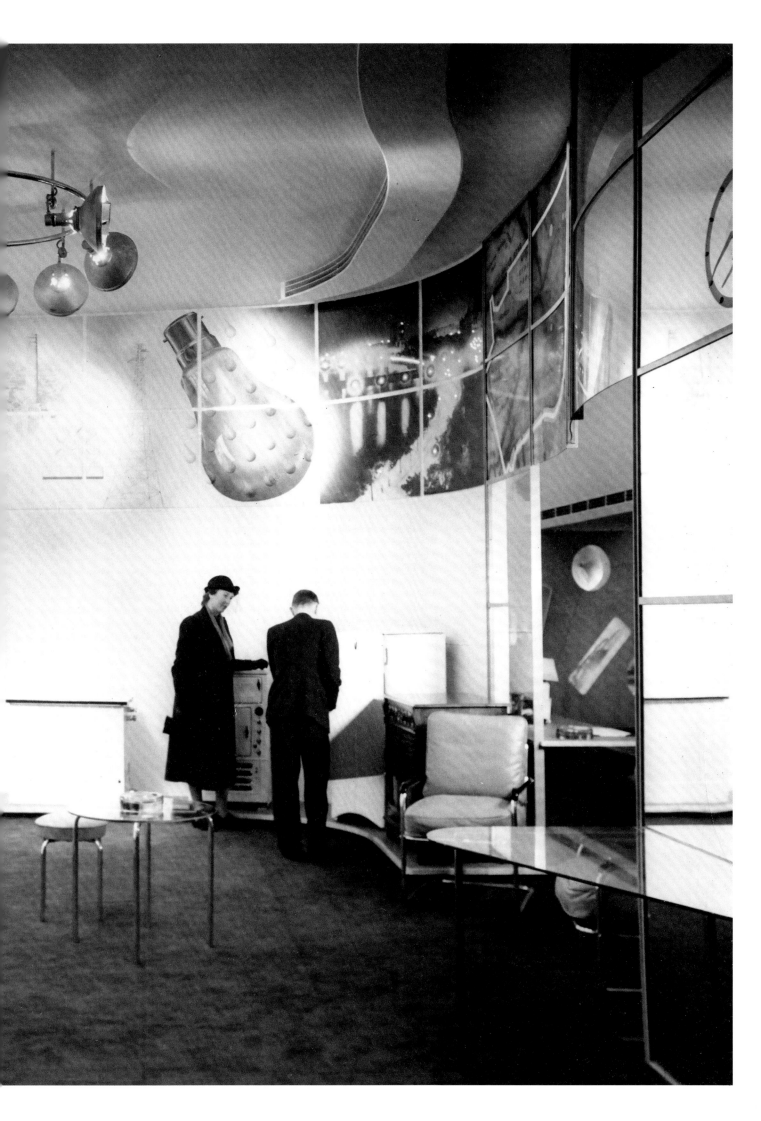

Moholy's activities with MARS also intensified. A major exhibition was planned for 1938, aimed at communicating the benefits of modern architecture and planning to a wider public; Moholy was a member of the exhibition committee, together with Fry, Godfrey Samuel of Tecton and Serge Chermayeff. While the project was being developed in early 1937, Gropius accepted a teaching position at Harvard University and prepared to leave the country. A dinner in his honour was organised by the RIBA Librarian, Edward 'Bobby' Carter, held at the Trocadero and attended by a who's who of London's modern architectural community. Moholy designed the dinner menu, or 'Bill of Fare', which exemplifies the graphic style of his English period, and was described by the *Architect and Building News* as 'a gorgeous specimen of the gay art of Moholy-Nagy'.[22]

Right:
Letter from László Moholy-Nagy to Edward 'Bobby' Carter, 28 March 1937

7, FARM WALK LONDON, N.W.11 • TELEPHONE: SPEEDWELL 8847

28/3/37

Dear Carter,

It is a wonderful Easter morning
thus I feel, it is the best time to
congratulate you and thank you
for your marvellous achievement
for the Gropius dinner. You worked so
hard and so in the background
that now I slowly think you always
do in the same manner. Nevertheless,
it is a good feeling to know that we
have such a friend. With

Kindest regards
Yours
L. Moholy-Nagy

p.s. I am enclosing a cheque for Giedion's
participation at Gropius dinner.

TOASTS

HIS MAJESTY THE KING
Proposed by the Chairman

WALTER GROPIUS AND MRS. GROPIUS
Proposed by the Chairman, and supported by
W. G. Constable, Slade Professor of Fine Art, Cambridge University
Ray Atherton, Counsellor of the Embassy of the U.S.A.
Maxwell Fry
Geoffrey Faber
Henry Morris
Lionel B. Budden, Roscoe Professor of Architecture, Liverpool University
Herbert Read
Walter Gropius will reply

CHAIRMAN: Dr. Julian Huxley

Dinner to Professor Walter Gropius, March 9th, 1937, on the occasion of his leaving England for Harvard University

BILL OF FARE

	Oysters
Tio Pepe	*Turtle Soup*
	Cheese Straws
Pouilly, 1929	*Boiled Scotch Salmon, Lobster Sauce*
	Cucumber
Volnay, 1924	*Aylesbury Duckling, Apple Sauce*
	French Beans
	Roast Potatoes
	Salad
	Iced Nectarine Melba
	Petits Fours
Dow's 1912 Port	*Fruit*
	Cheese
Liqueur Brandy	*Coffee*

Kindly printed by Lund Hu...
from the design by Moho...

Above and right:
Menu card for dinner in honour of Walter Gropius
(design: László Moholy-Nagy, 1937)

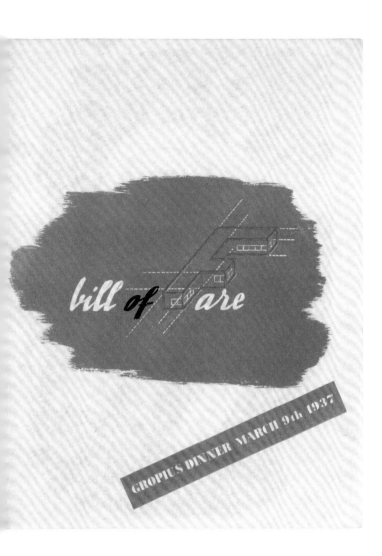

bill of fare

GROPIUS DINNER MARCH 9th 1937

LPHABETICAL LIST OF GUESTS

Professor Abercrombie	6	
Mrs. Patrick Abercrombie	106	
Dr. Thomas Adams	127	
Mrs. Mary Adams	67	
Mr. E. W. Armstrong	84	
Mrs. E. W. Armstrong	102	
Mr. Ove Arup	25	
Mrs. Ove Arup	124	
Mr. D. Ascoli	109	
Mr. Ray Atherton	133	
Mr. D. Betts	95	
~~Mr. D. Betts's guest~~	96	
Mr. Eric L. Bird	18	
Mr. D. L. Bridgwater	93	
Mrs. D. L. Bridgwater	22	
Professor Lionel Budden	125	
Mr. William Cahn	94	
Mr. Noel Carrington	123	
Mr. Edward Carter	57	
Mrs. Edward Carter	51	
Mr. Cyril Carter	42	
Mr. F. Charles	112	
Mr. Serge Chermayeff	53	
Mrs. Serge Chermayeff	28	
Mr. Wells Coates	64	
Mr. J. M. Cohen	62	
Mrs. J. M. Cohen	65	
Mr. Willard Connely	55	
Professor W. G. Constable	105	
Mr. George Cooke	59	
Mrs. George Cooke	122	
Mr. Graham Cunningham	97	
Mrs. Graham Cunningham	119	
Mrs. E. Curtis	117	
Mr. D. Curtis	116	
Mr. Amyas Connell		
Mrs. Hugh Dalton	32	
Mr. W. Davies	121	
Mr. Richard de la Mare	10	
Miss Elizabeth Denby	128	
Mr. T. Denman	103	
Mrs. T. Denman	108	
Mr. E. M. O'R. Dickey	129	
Mrs. E. M. O'R. Dickey	54	
Mr. J. G. F. Donaldson	74	
Mrs. J. G. F. Donaldson	63	
Mr. Geoffrey Faber	4	
Mr. Alexander Farquharson	77	
Miss Ellen Frank	35	

F	Mr. Ernst L. Freud	46
	Mrs. Ernst Freud	5
	Mr. E. Maxwell Fry	83
	Mrs. E. Maxwell Fry	88
G	Dr. Siegfried Giedion	66
	Mr. John Gloag	17
	Mrs. John Gloag	78
	Mr. V. H. Goldsmith	79
	Mrs. Ise Gropius	1
	Dr. Walter Gropius	135
H	Mr. Val Harding	15
	Mrs. Val Harding	58
	Dr. R. Hargreaves	24
	Mrs. Hargreaves	37
	Mrs. Gillian Harrison	7
	Mr. Ashley Havinden	39
	Mrs. Ashley Havinden	82
	Mr. G. Brian Herbert	111
	Professor W. G. Holford	29
	Mrs. W. G. Holford	9
	Dr. Julian Huxley	●
	Mrs. Julian Huxley	3
I	Mr. Gilbert Inglefield	20
	Mrs. Gilbert Inglefield	115
J	Mr. R. T. James	92
	Mrs. R. T. James	19
K	Mr. H. Kallenbach	21
	Mr. B. Katz	120
	Mr. C. J. Kavanagh	101
	Miss Gertrude Kolman	56
L	~~Mr. R. S. Lambert~~	33
	Miss Judith Ledeboer	80
	Miss Jane Lidderdale	13
M	Sir Ian MacAlister	31
	Lady MacAlister	134
	Mrs. Edward Maufe	43
	Mr. J. E. R. McDonagh	34
	Mrs. J. E. R. McDonagh	100
	Mr. Charles Marriott	131
	Mrs. Charles Marriott	30
	Mr. Basil Marriott	99
	Mrs. Hartley Mason	45
	Mr. J. Duncan Miller	23

M	Mrs. J. Duncan Miller	71
	Professor L. Moholy-Nagy	72
	Mrs. Moholy-Nagy	132
	Mr. Henry Moore	47
	Mr. Henry Morris	70
	Mr. H. G. Murphy	87
N	Mr. Christopher Nicholson	38
	Mr. Max Nicholson	12
	Mr. Clifford Norton	14
	Mrs. Clifford Norton	104
P	Dr. N. Pevsner	61
	Miss M. E. Pheysey	126
	Dr. Arthur Upham Pope	16
	Mr. Fleetwood C. Pritchard	89
	Mrs. Fleetwood C. Pritchard	41
	Mr. J. Craven Pritchard	36
	Mrs. J. Craven Pritchard	69
Q	Mr. Hugh Quigley	90
R	Dr. M. Rachlis	86
	Mr. A. B. Read	40
	Mr. Herbert Read	68
	Professor C. H. Reilly	44
	Mr. Paul Reilly	60
	Mr. J. M. Richards	11
	Mr. Michael Ross	50
	Mr. Gordon Russell	52
S	~~Sir Herbert Samuel~~	
	Mr. Godfrey Samuel	48
	Mr. P. Morton Shand	8
	Mrs. P. Morton Shand	26
	Dr. S. Siegheim	76
	Mr. J. Dixon Spain	118
	Mr. C. D. Spragg	98
	Mrs. Cunninghame Strettle	110
	Mr. John Summerson	27
	Mr. Cyril Sweett	113
	Mrs. Cyril Sweett	91
V	Mr. R. Vaughan	114
	Mrs. Dorothea Ventris	75
W	Mr. C. H. Waddington	49
	Mrs. C. H. Waddington	73
	Sir Alexander Walker	107
	Lady Walston	130
	Mr. Richard Weininger	85
	Mr. H. G. Wells	2
	Mr. Clough Williams-Ellis	81

11th March, 1937.

Dear Moholy,

We had a meeting of the Mars
Exhibition Committee yesterday and fixed up for
Entwhistle to make a survey of the hall as soon
as the agreement is signed, which should be next
week. That is all that Entwhistle has been asked
to do but he is so full of enthusiasm that he has
proposed a variation on your plan as the result
of my telling him on one occasion, roughly what
your idea was. I cannot do otherwise than hand
you on his suggestion but he has been told that
a free hand will be left to you, subject only to
discussion with the other elected members of the
Exhibition Committee. At a later stage an Editorial
Committee may of course be appointed and Entwhistle
coopted.

Meanwhile perhaps you would keep
these notes as I shall be away for the next two
weeks. If you need any of my records in connections
with the Exhibition, for discussion with the other
members of the Committee, Fry and Chermayeff, they
can be delivered to you on demand from my secretary.

I hope you enjoyed the Gropius
dinner on Tuesday; I did very much.

Yours sincerely,

L. Moholy Nagy, Esq.,
7, Farm Walk,
N. W. 11.

1.

M A R S G R O U P

Memorandum of a Meeting held at
3-5, Burlington Gardens, W.1. on
Friday, 2nd April, 1937

PRESENT: Mr. J. M. Richards, Mr. Maxwell Fry,
 Mr. Moholy-Nagi, Mr. G. Samuel.

The Organiser was advised that Mr. Maxwell Fry
would be responsible for the collection of Sub-
scriptions, and all instructions upon this subject
should be taken from him.
Mr. Samuel was to be responsible for the invitations
to all Exhibitors, whilst Mr. Moholy-Nagi had ac-
cepted responsibility for the planning and lay-out
of the Exhibition.

It was decided to circularise Members immediately,
notifying them of the arrangements for the Exhibi-
tion made to date, and a report was drafted to be
sent out by the Organiser, together with a copy of
the printed Brochure.

COLLECTION OF SUBSCRIPTIONS: The Organiser arranged to forward a
 list of the Industries and Trades to Mr. Fry, who
 would in due course advise him which Member of the
 Group would approach each Industry, and the Organiser
 would then make it his business to follow the matter
 up with the respective Members.
 In the meantime, Electric Light, Gas, Steel and Con-
 crete Industries were being approached, whilst Metal
 Window Industry had already agreed its contribution.
 The Organiser was instructed to write and remind
 Mr. Emberton of his promise to approach the Concrete
 Industry in collaboration with Mr. Yorke, and at the
 same time advise him of Mr. Kavanagh's intention of
 convening a Meeting of the Steel and other groups.

2.

EXHIBITS: Mr. Samuel pointed out that the Exhibits would be
 divided into three sections: (1) photographs,
 models, etc; (2) texts; (3) material in kind.

1: Photographs, models, etc. Mr. Samuel would let the
 Organiser have a list on or about 9th April, when
 official invitations could be sent out.

2: Texts- These would be arranged for by Mr. Samuel
 himself nearer the date of the Exhibition.

3: Material in kind; This was dependent upon the lay-
 out of the Exhibition, and as soon as the working
 drawings were available the Organiser would be fur-
 nished with a list to whom application could be made.

WORKING DRAWINGS: Mr. Moholy-Nagi promised to have these ready by
 the end of April, when they could be sent out for
 tender.

CONTRACTORS: It was suggested that the Contractors might be appro-
 ached with a view to helping the Exhibition in the
 same way as other trades and industries, and the
 Organiser was instructed to write to Mr. Serge Cher-
 mayeff with a view to obtaining his comments upon
 this suggestion, and also to ascertain if he would
 approach Messrs. Whiteley's.

PUBLICITY: The Organiser arranged to get in touch with Mrs.
 Zander, with a view to collaborating with her.

CATALOGUE: Mr. Moholy-Nagi suggested that he should communicate
 with Mr. Ashley Havindon of Messrs. Crawford's, with
 a view to getting advice upon the obtaining of adver-
 tisements for the Catalogue. Mr. Fry stated that he
 had already written to Mr. Anderson for his comments.

Left:
Letter from Godfrey Samuel to
László Moholy-Nagy, 11 March 1937

Above:
First page of the memorandum of a
meeting of the MARS Group, 2 April 1937

<u>M A R S E X H I B I T I O N</u> 20/4/37

<u>Agreed Workers on Sections</u>

Worker	Section	Member to Contact
Clarke Hall	? Children	
Tecton	To think over what section they wish to take on and communicate with Samuel.	
Entwistle	Large room; curved wall. "Consistent Architecture"	
Goldfinger	Partition Game	Samuel to send details.
Shand	Photographs	Samuel to collect
Richards	Evening Lectures	
Samuely	Help with structural part.	
Exhibition Committee.	First Room	
Moholy-Nagy	Enlargements	
Barman	Transport (Publicity)	Fry

<u>Suggested members and work they might be willing to undertake</u>

Member	Work	Contact member
Praxis		Samuel
Löneberg		Samuel
McGrath		Samuel
Breuer) Yorke)	Living Room) ? Pergola)	Samuel
Boumphrey	Wireless Talks	Richards
Lucas		Samuel
Dawson)) Earley)		Penn to enquire and instruct them to ring Samuel
Dugdale		Samuel
Gibberd	Blinds ?	Richards
Hastings		Richards
Kirby		Samuel

Continued

Suggested members (Continued)

Member	Work	Contact member
Mallows		Samuel
Nicholson)		
Casson)		Richards
Pleydell-Bouverie		Fry
Scholberg	Structural ?	Richards
Sheppard		Samuel
Zweigenthal		Samuel

General Notes

Powell - Birmingham Mail. Moholy-Nagy to introduce Penn who will
see him in Birmingham. Fry to write up
officially. Bradshaw to send leaflet.

Models - Clarke Hall's School.

Peepshow - Fry to investigate.

Travel - Hartland Thomas (Bristol)

Mollo and Egan - Samuel

1/- Entrance- payable upstairs. Consult Bradshaw.

Left and above:
List of sections of MARS exhibition, 20 April 1937

Gropius's departure was probably the first step in the process of disillusionment that Moholy felt with regard to his prospects in the country; most of all, he missed teaching, which he possibly considered his primary calling. In Britain he had received recognition: he had been made an honorary member of the Arts Societies of Oxford and Cambridge, and of the Design Institute in London, and had succeeded in staging both an exhibition of his photographs at the Royal Photographic Society and one of his paintings at the London Gallery, for which he had designed invitations and posters. In Britain he had also achieved a remarkable body of work across many disciplines (including painting, which he took up again in late 1936) and had found a group of like-minded individuals in the progressive cultural community of the capital that had helped him both gain employment and develop his artistic thought; he stayed in touch with several of them for the rest of his life. However, the country as a whole was still too conservative for his ideas, and the impossibility of recreating something akin to what the Bauhaus had represented made him once again desire to move on. Thanks to Gropius's efforts, in the summer of 1937 he was offered a position as director of a new design school in Chicago – which he accepted, to Fry's great disappointment. Fry wrote to Gropius: 'how much we will miss Moholy! His wife told me today that his appointment was confirmed and my heart sank a lot'.

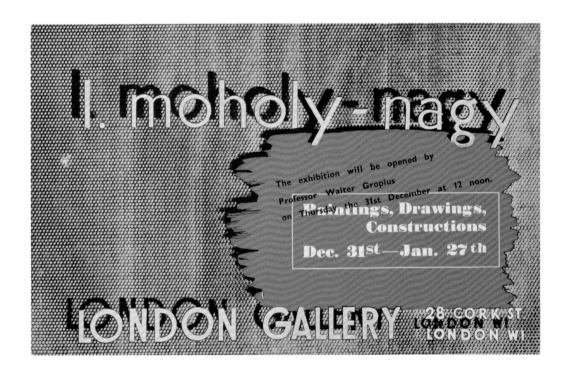

Above:
Invitation to the opening of the exhibition of László Moholy-Nagy's work at the London Gallery on 31 December 1936 (design: László Moholy-Nagy)

"For the first time since the Bauhaus days he found men and women with whom to discuss his work. The unique English capacity for friendship, an objective unemotional association which warmed and stimulated without obligation, seemed particularly strong among London artists and intellectuals. The young architects of the MARS group supplied many new ideas. [...] 'Peter' Norton, vivacious owner of the London Gallery, organized Moholy's first English one-man show, which had a startling and gratifying response. [...] By and by a close circle developed – Herbert Read, Henry Moore, Jack Pritchard, Jim Crowther, Julian Huxley, Barbara Hepworth and Ben Nicholson. [...] Read's genuine convictions on the educational importance of art, his willingness to listen and to absorb [...] created a lasting friendship. [...] And we all benefitted from contact with Jack Pritchard, manufacturer of Marcel Breuer's plywood furniture and generous host to many a Continental refugee in his ever-open Lawn Road Flats. When we went to America it was the irreplaceable loss of this companionship that hurt most."

Sibyl Moholy-Nagy, *Moholy-Nagy: Experiment in Totality* [23]

England's loss is America's gain. No more suitable principal than Prof. Moholy-Nagy could have been found for the New Bauhaus (above is the cover of the prospectus) that opened this autumn in Chicago. In the original Bauhaus at Dessau Moholy-Nagy was one of the most successful teachers, and in Chicago he will still have the benefit of Gropius's presence on an advisory committee.

woe betide the man who lays an irreverent hand on an old-world cottage, or half-timbered pub, even if they are entirely lacking in every architectural merit, he will never earn forgiveness, and must expect to be cast into the outer darkness with those who are unkind to cats, rather than to human beings.

Hungarian with a Hungarian restaurant and Lager Beer Hall, Steiner's Hungarian Cadets band, a Tzigane Orchestra, Hungarian Ice Caverns, a haunted castle and a Hungarian working coal mine.

1909

In 1909 Earls Court staged an exhibition dedicated to the Golden West containing " a magnificent display of America's products and inventions."

1910—11

The Exhibition, already in decline, faded out altogether during this year but in the following year an attempt was made to revive the purely entertainment side but there was no attempt to hold an exhibition on the grand scale. This is curious as 1911 was Coronation year.

1902

In the year 1902 the Exhibition was called " Paris in London."

1903

The next exhibition was an International Fire Exhibition intended to popularize the study of protection from fire.

1912

The last Exhibition of any importance was " Shakespeare's England," opened in 1912,

1913

In 1913 the Exhibition was dedicated to the Imperial Services.

1914

cock, of Wesleyan University, Connecticut. This month we are able to publish a reply by Prof. Hitchcock. This is printed below and is preceded by the original letter from the Taliesin Fellowship and also by another letter sent from Taliesin at the same time direct to Prof. Hitchcock.

The Taliesin Fellowship to Prof. H. R. Hitchcock.

My dear Professor Hitchcock : I have just read your article in the London " Review " and am curious about your reference to Mr. Frank Lloyd Wright in the past tense : " For, I suppose, there might conceivably grow up in a vacuum, without benefit of intention, a sense of form wholly of the twentieth century and wholly American, as was Wright's in the days when he was an active architect before the war."

Mr. Wright is building five important buildings right now that bear the same relation to buildings to-day as the ones you refer to then bore to those around them. Growth has been steady and consistent. He has designed at least twenty buildings, not to mention Broadacre City, in the past three years. He is very active : active enough to keep

According to Fry, he and Moholy had done most of the work on the MARS exhibition, so replacing him must have been a great concern; however, the project had to be completed, and Russian-born architect Misha Black assumed Moholy's duties. The show that opened at the New Burlington Galleries in January 1938 was greatly influential on British exhibition design; its dynamic and visually stimulating character, with the use of photomontage, murals and display boxes, highlights Moholy-Nagy's influence and the impact that working with him and Gropius had on Fry's work. The *Architectural Review* marked Moholy's departure with an acknowledgement of Britain's lost opportunity of holding on to a remarkable talent.

Above:
Architectural Review, November 1937, p.221

Right:
MARS Group Exhibition, New Burlington Galleries, London (photograph: Sydney Newbery, 1938)

Right:
MARS Group Exhibition, New Burlington Galleries,
London (photograph: Sydney Newbery, 1938)

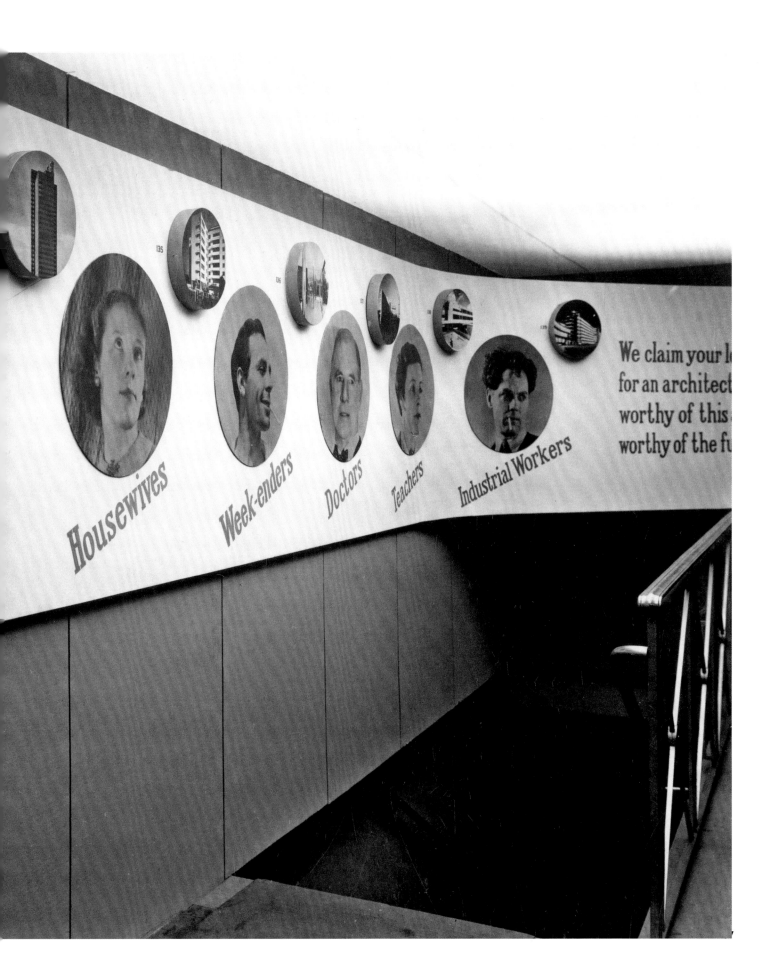

Left:
MARS Group Exhibition, New Burlington Galleries,
London (photograph: Alfred Cracknell, 1938)

Above:
Cartoon 'Breuer and Moholy-Nagy leave
for America' by Gordon Cullen, *Architects'
Journal*, 13 January 1938, p.38

The nine years he spent in Chicago before his premature death once again brought both satisfaction and disappointment for Moholy-Nagy. He intermittently kept in touch with many of his British friends, from Ben Nicholson and Barbara Hepworth to Jack Pritchard, who visited Moholy in Chicago in 1944 and was given a tour of his design school; Herbert Read lectured in Chicago at his invitation in 1946. Later that year Pritchard heard from CIAM founder Sigfried Giedion that his close friend Moholy had died from leukaemia, and Pritchard immediately informed Herbert Read; both were profoundly affected by the news. In his message of reply to Pritchard, Read writes: 'Apart from the domestic side of the tragedy, there is the end of a great experiment. No one can replace Moholy.'[24] Pritchard also wrote to Gropius to express his sympathy,

reflecting: 'I will always treasure the contact I had with him here. He was so stimulating and sincere. The visit to Chicago two years ago was one of the most informative periods of my life.'[25] Bernard Fergusson learnt of Moholy's death just as he was planning to renew contact with him: 'Not until then did I realize that I had been hobnobbing unawares with a celebrity. I had thought of him, and still think of him, only as an extraordinarily nice man.'[26] Leslie Martin celebrated Moholy's great talent as an educator in an article published by the *Architectural Review* in June 1947. Three years later, in May 1950, the RIBA hosted a lecture on his work organised in collaboration with the ICA and delivered by his wife Sibyl – once again the British architectural community recognised the artist László Moholy-Nagy as a great influence on their own discipline.

Telephone : Langham 5721-7 *Telegrams : Ribazo Wesdo London*

ROYAL INSTITUTE OF BRITISH ARCHITECTS

Incorporated by Royal Charters of William IV, Victoria, Edward VII & George V

66 PORTLAND PLACE, LONDON W.1

D.700/50.

The Institute of Contemporary Arts and the

Royal Institute of British Architects

have arranged for an illustrated lecture to be given on

THE WORK OF MOHOLY-NAGY

by Sybil Moholy-Nagy at the Royal Institute of British Architects,
66 Portland Place, London, W.1. Wednesday, May 24th, 1950 at
6 p.m. Refreshments 5.15
Admission Free.

Above:
Invitation to the lecture on László Moholy-Nagy's work given by his wife Sibyl at the Royal Institute of British Architects on 24 May 1950

TIMELINE

1895 • Born in Borsód (now Bácsborsód), Hungary

1915–18 • Fights in the First World War in the ranks of the
Austro-Hungarian Army

1920 • Moves to Berlin

1921 • Marries photographer Lucia Schulz (thereafter Lucia Moholy)

1922 • Meets Walter Gropius, who visits Moholy-Nagy's exhibition
at Der Sturm gallery
• Begins making photograms with Lucia

1923 • Invited by Gropius to teach at the Staatliches Bauhaus in
Weimar, where he takes over the foundation course from
Johannes Itten

1924 • Starts work with Gropius on the Bauhausbücher (Bauhaus
Books) series
• Experiments with photo-collages

1925 • Moves with the Bauhaus to Dessau
• Writes the eighth Bauhaus Book, *Malerei, Photographie, Film*
(*Painting, Photography, Film*)

1928 • Resigns from the Bauhaus along with Gropius and others,
and returns to Berlin

1929 • Separates from Lucia
• Writes his second Bauhaus Book, *Von Material zu Architektur*
(published in English in 1932 as *The New Vision*)
• Selects works for the Werkbund exhibition *Film und Foto* in
Stuttgart, where he also exhibits his own photographs

1930 • His Light Space Modulator, a kinetic sculpture, becomes the
subject of his best-known film *Lichtspiel schwarz weiss grau*
(*Light Display: Black, White, Grey*)

1931 • Meets Sibyl Pietzsch, who becomes his second wife

1933 • Takes part in the fourth meeting of the CIAM (Congrès
international d'architecture moderne), held in Greece

1934 • Moves to Amsterdam

1935 • Moves to London in May

1937 • Leaves London in the summer for the United States
• Appointed director of a new design school in Chicago, which
he calls The New Bauhaus

1939 • Reopens the school as The School of Design in Chicago

1946 • Dies of leukaemia on 24 November in Chicago

1947 • His last book, *Vision in Motion*, is published posthumously

REFERENCES FOR QUOTATIONS

1 • Herbert Read, 'A New Humanism' in *Architectural Review*, October 1935, p.151

2 • László Moholy-Nagy, quoted in Terence Senter, 'László Moholy-Nagy: The Transitional Years' in Achim Borchardt-Hume (ed.), *Albers and Moholy-Nagy: From the Bauhaus to the New World* (London, 2006), p.86

3 • Letter from László Moholy-Nagy to Herbert Read, quoted in Krisztina Passuth, *Moholy-Nagy* (London, 1985), p.405

4 • Sibyl Moholy-Nagy, *Moholy-Nagy: Experiment in Totality* (New York, 1950), p.117

5 • Jack Pritchard, *View from a Long Chair* (London, 1984), p.122

6 • Sibyl Moholy-Nagy, *Moholy-Nagy: Experiment in Totality*, pp 118, 120

7 • Pritchard, *View from a Long Chair*, p.122

8 • Ashley Havinden, quoted in Alice Strang, Anne Simpson and Richard Hollis, *Advertising and the Artist: Ashley Havinden* (Edinburgh, 2003), p.58

9 • David Wainwright, *The British Tradition: Simpson – a World of Style* (London, 1996), p.27

10 • *Architect & Building News*, 8 May 1936, p.161

11 • Berthold Lubetkin, quoted in Passuth, *Moholy-Nagy*, p. 65

12 • László Moholy-Nagy, quoted in Terence Senter, 'Moholy-Nagy's English Photography' in *Burlington Magazine*, November 1981, p.663

13 • Bernard Fergusson in 'A Hungarian at Eton and Oxford', *The Times* Saturday Review, 6 August 1977, p.5

14 • Ibid.

15 • Penelope Betjeman, quoted in Lloyd C. Engelbrecht, *Moholy-Nagy: Mentor to Modernism* (Cincinnati, 2009), pp 523, 524

16 • John Betjeman in 'A Hungarian at Eton and Oxford', p.5

17 • James Maude Richards, *Memoirs of an Unjust Fella* (London, 1980), p.134

18 • Pritchard, *View from a Long Chair*, p.124

19 • Richards, *Memoirs of an Unjust Fella*, p.134

20 • Letter from E. Maxwell Fry to Walter Gropius, 17 August 1937 (RIBA Collections)

21 • E. Maxwell Fry, *Autobiographical Sketches*, (London, 1975), p.156

22 • *Architect & Building News*, 12 March 1937, p.319

23 • Sibyl Moholy-Nagy, *Moholy-Nagy: Experiment in Totality*, pp 135–7

24 • Letter from Herbert Read to Jack Pritchard, 29 November 1946 (UEA Archives)

25 • Letter from Jack Pritchard to Walter Gropius, 29 November 1946 (UEA Archives)

26 • Fergusson in 'A Hungarian at Eton and Oxford', p.5

SELECT BIBLIOGRAPHY

Mary Benedetta, *The Street Markets of London* (London, 1936)

John Betjeman, *An Oxford University Chest* (London, 1938)

John Betjeman, Bernard Fergusson, 'A Hungarian at Eton and Oxford' in *The Times* ('Saturday Review'), 6 August 1977

Lloyd C. Engelbrecht, *Moholy-Nagy: Mentor to Modernism* (Cincinnati, 2009)

Mira Engler, *Cut and Paste Urban Landscape: The Work of Gordon Cullen* (London, 2016)

Bernard Fergusson, *Eton Portrait* (London, 1937)

Iain Jackson and Jessica Holland, *The Architecture of Edwin Maxwell Fry and Jane Drew: Twentieth Century Architecture, Pioneer Modernism and the Tropics* (Farnham, 2014)

Leslie Martin, Ben Nicholson and Naum Gabo (eds), *Circle: International Survey of Constructive Art* (London, 1937)

Leslie Martin, 'László Moholy-Nagy and the Chicago Institute of Design' in *Architectural Review*, June 1947, pp. 225–6

Edwin Maxwell Fry, *Autobiographical Sketches* (London, 1975)

'Modern Art and Architecture' in *RIBA Journal*, 9 January 1937, p. 209-219

László Moholy-Nagy, letters to Ben Nicholson and to Barbara Hepworth, Tate Archives

Sibyl Moholy-Nagy, *Moholy-Nagy: Experiment in Totality* (New York, 1950)

Philip Morton Shand, 'New Eyes for Old' in *Architectural Review*, January 1934, pp. 11–12

Krisztina Passuth and Terence Senter, *L. Moholy-Nagy* (London, 1980)

Krisztina Passuth, *Moholy-Nagy* (London, 1985)

Alan Powers, *Serge Chermayeff: Designer, Architect, Teacher* (London, 2001)

Jack Pritchard, *View from a Long Chair* (London, 1984)

Herbert Read, *Art and Industry* (London, 1934)

James Maude Richards, *Memoirs of an Unjust Fella* (London, 1980)

Terence Senter, 'Moholy-Nagy's English Photography' in *Burlington Magazine*, November 1981

Terence Senter, 'László Moholy-Nagy: The Transitional Years' in Achim Borchardt-Hume (ed.), *Albers and Moholy-Nagy: From the Bauhaus to the New World* (London, 2006)

Alice Strang, Anne Simpson and Richard Hollis, *Advertising and the Artist: Ashley Havinden* (Edinburgh, 2003)

David Wainwright, *The British Tradition: Simpson – a World of Style* (London, 1996)

Nigel Warburton, *Ernö Goldfinger: The Life of an Architect* (London, 2003)

ACKNOWLEDGEMENTS

IMAGE CREDITS

This publication was supported by a generous grant from the Moholy-Nagy Foundation, and I am particularly grateful to Dr Hattula Moholy-Nagy for her kind assistance. Warm thanks also go to Dr Christopher Adams, Prof. Oliver Botar, Magnus Englund, Dr Marco Iuliano and Prof. Angelo Maggi, who have all contributed in various ways to the realisation of this project.

Alvar Aalto Estate/Alvar Aalto Museum
p.14

Architectural Press Archive / RIBA Collections
p.4–5, 7, 25, 38–39, 54-56, 63, 67, 68–69, 70, 71, 85, 86–87, 88–89

Art Gallery of New South Wales
László Moholy-Nagy (Hungary; United States of America, b.1895, d.1946)
An outline of the universe 1930
gelatine silver photograph, vintage, 23.9 × 18.2 cm
Purchased with funds provided by the Photography Collection
Benefactors' Program 2001
Photo: Jenni Carter, AGNSW
3.2001
p.15

Buahaus-Archiv Berlin / VG Bild-Kunst Bonn
p.9

Keystone Press / Alamy Stock Photo
p.60

Private Collection
p.24, 43–47

RIBA Collections
p.11, 12, 16, 20, 21, 22–23, 26–27, 28, 37, 49–51, 52, 57, 59, 61, 62, 64, 65, 66, 72–73, 75, 76–77, 78, 79, 80–81, 84, 90, 91

© TfL from the London Transport Museum collection
p.33, 34, 35

Courtesy of Hattula Moholy-Nagy
p.18, 36, 41, 82, 96

Courtesy of the Pritchard Papers, University of East Anglia
p.30, 31, 32

Next page:
Detail of advert for the film *Lobsters*
(design: László Moholy-Nagy, 1936)

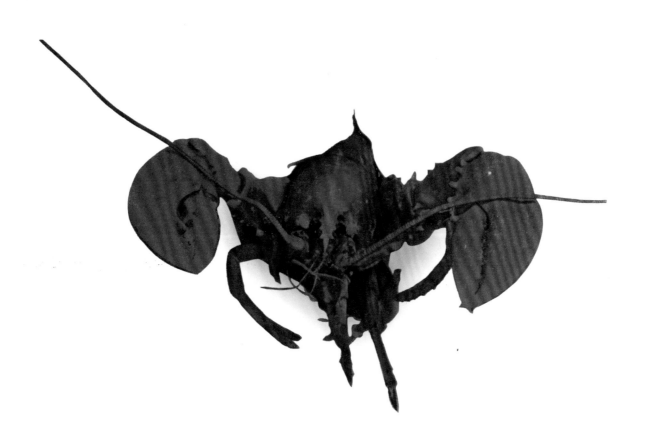